Infrared Landscape Photography

Todd Damiano

Amherst Media, Inc. ■ Buffalo, New York

Published by:
Amherst Media, Inc.
P.O. Box 586
Amherst, NY 14226
Fax: (716) 874-4508

Publisher: Craig Alesse
Senior Editor/Project Manager: Michelle Perkins
Assistant Editor: Matthew A. Kreib
Copy Editor: Richard Lynch
Image Technician: John Gryta

ISBN: 0-936262-82-6
Library of Congress Card Catalog Number: 98-74044

Printed in the United States of America
10 9 8 7 6 5 4 3 2 1

Introduction

This book explores the possibilities of one technique for representing the landscape, namely the use of black and white infrared film. As you will see, infrared photography offers photographers countless opportunities to capture the landscape in unique ways. With plant life rendered in a ghostly glowing white and dynamically dark skies, infrared photography yields dramatic and ethereal landscapes with a haunting beauty that sets them apart from other landscape photography.

It is assumed that the readers of this book will have a basic understanding of camera usage, as well as a basic understanding of techniques for working with infrared. Some sections of the book also deal with darkroom techniques. Although it is not imperative that you process and print your own film to make use of this book, basic knowledge of darkroom techniques will be helpful.

The material in this volume is organized in brief, easy to read and understand sections. Each image is analyzed directly, explaining how it was created and how to achieve similar results. Included are topics such as composition, evaluating subjects, what to avoid, tips for working in the field, ideas for the darkroom, and a number of other subjects important to infrared landscape photography.

Infrared landscape photography is a fascinating and highly creative process that will allow you to depict the world around you in a fresh way. With the techniques in this book you will be well on your way.

About the Author

Todd Damiano is a professional photographer from Berkeley, California. In this volume, Todd examines images he shot throughout the picturesque deserts of California, New Mexico, and Arizona. All the photographs were shot using a Pentax 6x7 camera with Konica infrared film. The images depicting ancient ruins in the American Southwest are also part of an ongoing series that will continue with work from a number of sites in Mexico and Latin America.

Photo by Joe Glass

Composition

When I shoot infrared, I look for locations that have unusual features, strange rock formations, and unique historical architecture. These locations, when shot with infrared, take on a surreal presence. I compose as if I were setting a stage with props or painting on canvas the scene before me. First, I find a background that consists of interesting shapes and tones, then I search the area for available elements that work well visually in front of it. This could be a stream with an appealing line, an interesting arrangement of rocks or foliage – anything that creates a setting arranged in a way that appeals aesthetically to the viewer. One should make an effort to compose the scene such that the eye of the viewer is led through it step by step, using the natural elements found in the landscape.

Exposure

When a specific shot is found, compose it to your liking and make at least two exposures (if not more). Infrared can present problems with focusing, so making extra exposures ensures, at the very least, that you will have a sharp negative. If the shot is truly spectacular, shoot several. For insurance, don't feel comfortable making only a single exposure of a scene you think will produce a wonderful print. Too many strange things can, and do, happen: a scratched negative, dirty light tables, technical glitches with chemistry – the world is full of film demons. Ultimately, film is extremely inexpensive compared to the time and effort, not to mention the monetary expense, that go into making a nice print.

Infrared Light

The spectrum of light visible to the human eye ranges from 400-700 nanometers. Just beyond the red wavelengths, from 700-900 nanometers, lie infrared wavelengths. Infrared films are sensitive to these infrared wavelengths, as well as to all wavelengths of visible light. Black and white films sensitive to the wavelengths found in this area of the spectrum have become more readily available from a number of manufacturers due to the their increasing popularity. Originally designed for scientific purposes, infrared film has become so popular that Kodak, the first to offer this type of film, must now compete with Ilford and Konica in the market. Although each are described as infrared, each brand of film possesses different characteristics which can make choosing where to start somewhat difficult. Turn to pages 6 through 8 for an overview of the infrared films available on the market today.

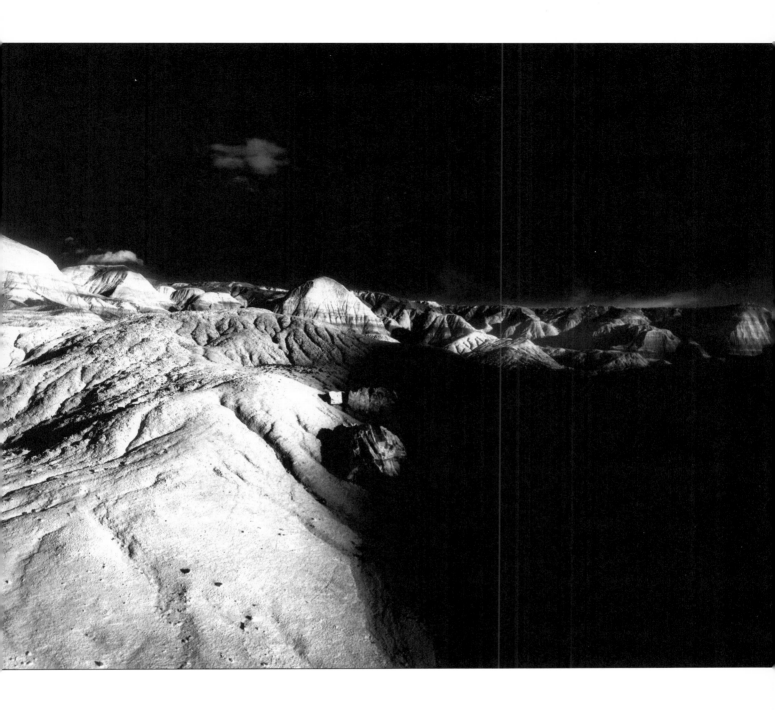

■ Kodak Infrared FIlm

Kodak infrared film is the most sensitive, registering infrared waves up to 900 nanometers. It therefore produces the most dramatic images. When used with an opaque filter the results are truly incredible, with glowing halos and brilliant white foliage. The film comes in two sizes, 35mm and the only 4x5 infrared film available. One of the drawbacks of using this extra sensitive film is that it requires the photographer to load the camera in darkness. Failing to do this will leave the first six or seven frames fogged. All it takes is opening the plastic canister in daylight and the damage is done. When loading on location, simply remember to do so using a changing bag. The grain of this film is also rather severe, almost equivalent to the high speed TMZ. Additionally, the film is more susceptible to problems related to humidity, fingerprints, and static, although these can be virtually eliminated with a sizeable amount of patience and some experience. Anyone willing to submit themselves to the somewhat tedious peculiarities of this film will be rewarded with some incredibly dramatic images.

■ Focusing

When focusing using Kodak infrared, make sure to experiment using the infrared mark on the barrel of most lenses. The reason for this is that infrared light is longer in wavelength than visible light which makes the focus point further from the camera lens. Therefore, the focus must be adjusted before making the exposure. To do this, simply focus the shot as if it were any other film, note the distance indicated on the lens barrel, then move that distance to line up with the infrared marker, usually orange in color. This should ensure a properly focused shot.

■ Exposure

Rate the Kodak film at ASA 50 and use a red filter. Exposures may vary and testing will be of great use. A good place to start is at f-8 with a shutter speed of $1/_{250}$ second. Remember this is a film sensitive to light waves that neither the camera light meter nor the human eye can see; therefore, experience with various situations is the best tool to determine proper exposures.

■ Processing

When processing Kodak infrared film, handle it very carefully as fingerprints can be a problem. Use D76 straight for 11 minutes at 68 degrees for the best results. This will keep the contrast down and retain as much detail in the shadows as possible.

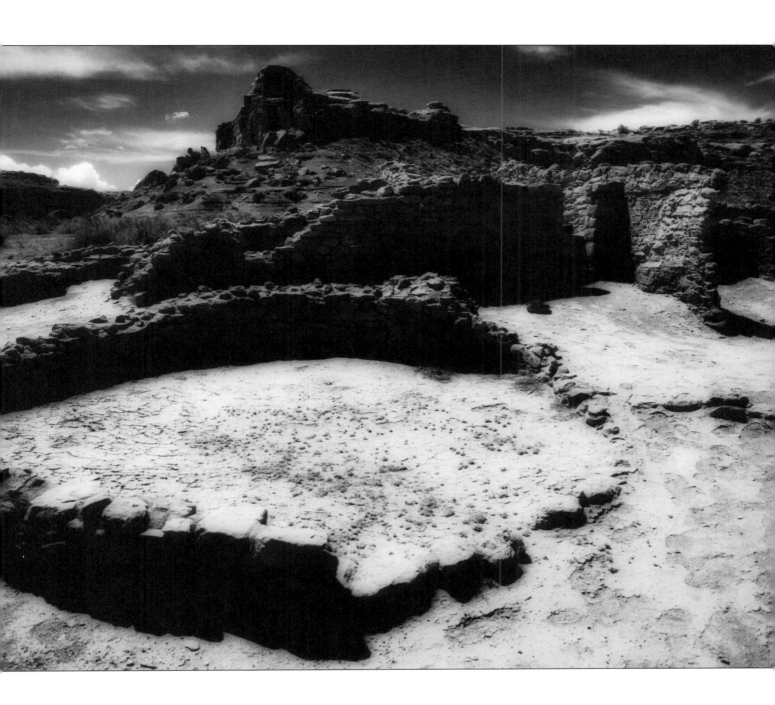

■ Characteristics of Infrared

Infrared has an unusual glow to it, one that becomes more pronounced as the exposure increases. Highlights within an infrared shot cast a halo-like appearance. In this shot, they are emphasized by a dramatic black sky and the typical deep shadows created by a film incapable of capturing much shadow detail.

■ Konica IR Film

Konica offers a black and white infrared film called Infrared 750, which refers to the film's peak sensitivity at 750 nanometers. In terms of sensitivity, it falls between Kodak's infrared and that of any standard black and white film, creating images that look like neither of the two entirely. Metering through the lens with a #25 red filter, I rate Konica infrared film at 100. Exposures tend to range from *f*-5.6 to *f*-8 with a shutter speed of $\frac{1}{60}$ second on a bright sunny day. This contrasty film has a very slow ASA and therefore may require the use of a tripod, depending on the equipment and the available lighting. However, the images are dramatic and have the least grain of all the infrared films. Because this film is only slightly more red sensitive, it doesn't require loading in complete darkness, something I have found to be of great convenience.

■ Processing

When processing Konica, use either HC110 or D76. Both deliver excellent results. The HC110 adds a bit more contrast to the negative which may slightly reduce the shadow detail, while the D76 will deliver a finer grain and may reveal more of the detail in the shadow areas. I have found that the best processing time using HC110 is a dilution of 1:10, from the stock solution, for 6 $\frac{1}{2}$ minutes at 68 degrees. Using D76, straight process for 11 minutes at 68 degrees.

■ Availability

Another strong point to the Konica is the availability in both 35mm and 120. It is, however, somewhat less widely distributed than the Kodak product. Take note of the fact that Konica infrared film is produced once each spring. Because of this, anyone who enjoys shooting it would be well advised to fill the refrigerator when it becomes available.

■ Ilford IR Film

Ilford SFX film falls somewhere between what the Konica and Kodak offer in terms of both performance and the final results. The SFX, which is available in 35mm and now 120, is roughly the same sensitivity as the Konica. Again, that range tends to produce images that have something of an infrared glow, but still possesses something of a standard black and white appearance. Because Ilford's infrared film equals the range of the Konica's sensitivity, they share the convenience of allowing the photographer to load in broad daylight. This is a very helpful feature. Unfortunately, the SFX also shares a heavy grain structure equal to that of the Kodak infrared film. If a somewhat grainy image isn't a problem, this could be a very interesting film. Process the film using D76 straight for 10 minutes at 68 degrees.

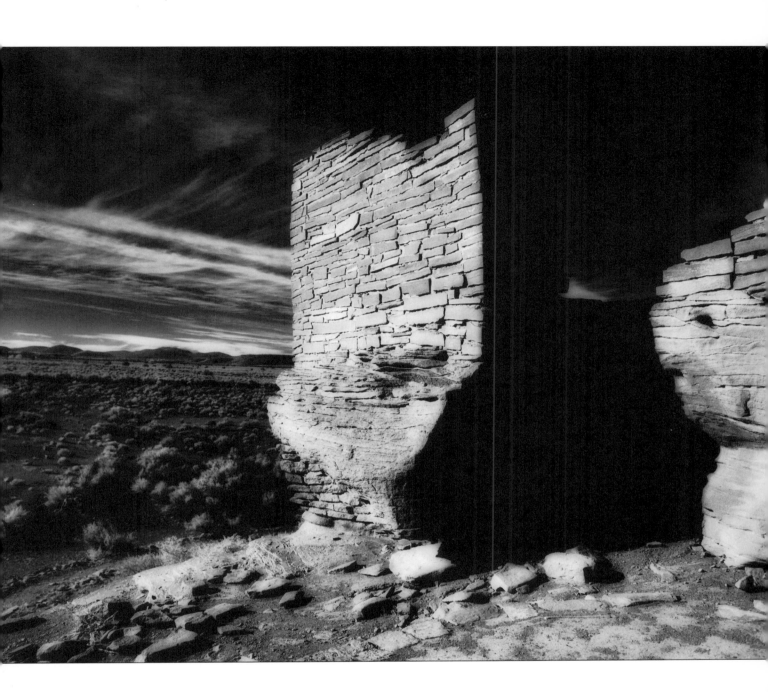

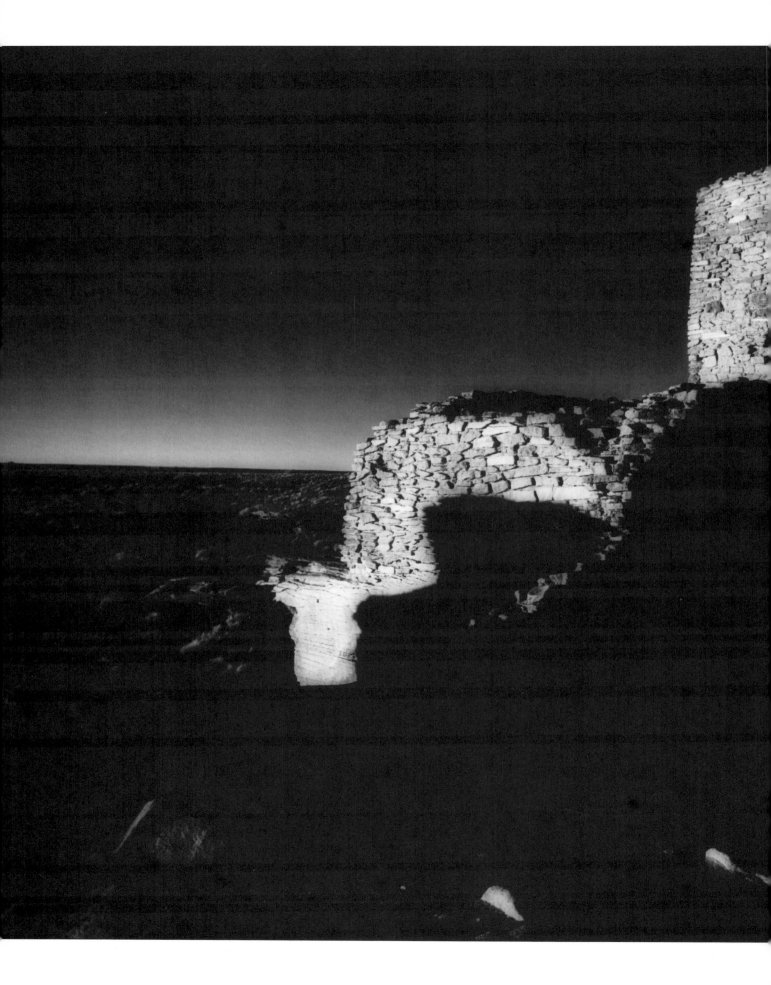

■ Light & Contrast

Shooting late in the day tends to add contrast due to lengthening shadows, less light and a consequent loss of detail in those shadows. Using infrared, which is notorious for overly dense highlights, at that time of day can produce negatives with overly dense highlights. Be careful not to overexpose the film in this situation. Bracket and record the results for future reference.

■ Composition

The square and uniform surface of this subject, combined with the strong horizontals and verticals, presented a challenge in terms of the composition. At other locations, such as Chaco Canyon and Wupatki, the building materials incorporated into the structures varied from small slats of rock to larger boulders. This allowed me to feature the materials themselves as the subject. At each location, I use these differing architectural features as a guide to help define the photographs.

■ Metering

There are times when a light meter can mislead the photographer into believing the exposure is correct — especially when shooting a white subject. It may be best to underexpose in this type of situation. Remember that infrared film is sensitive to both visible light rays and to infrared light, which is invisible both to the human eye and to light meters.

■ Exposure

To reduce the chance of overexposing the film while shooting the brilliant white wall in direct sunlight, I needed to stop down. It is quite easy to overlook this detail when evaluating a scene, but the film will not overlook it. You must be extremely observant and compensate for these bright elements. Even though infrared film is very slow, it requires the photographer to make precise exposures. Because of its high contrast, infrared film is very unforgiving in terms of exposure. A little too much and the highlights are blocked up, too little and the image becomes dark and muddy.

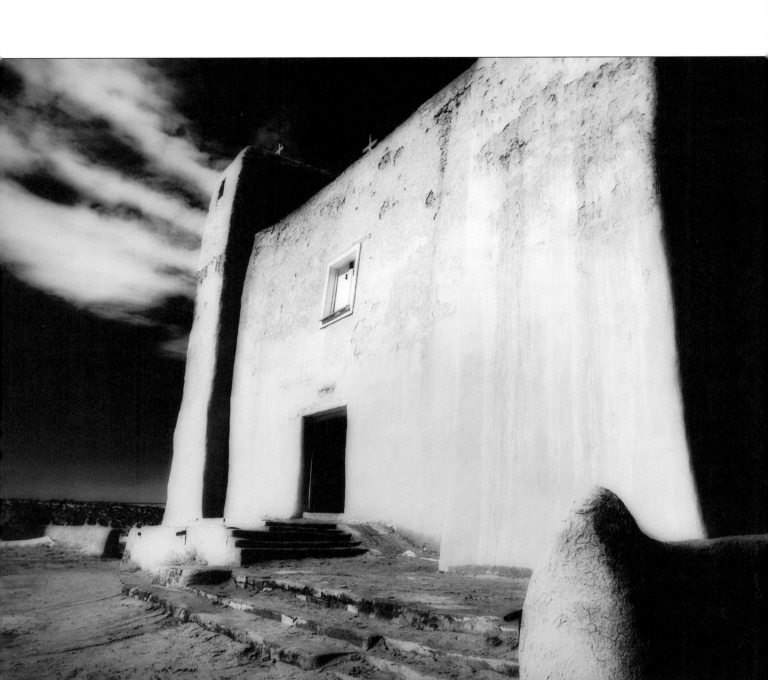

■ Vignetting

This image is an example of how infrared can create a vignetted appearance in an image. This means that the edges of the photograph appear somewhat darker than the central portions of the image. This effect is very common, and it appears in many landscape shots, depending on the subject and its composition. There are times when the vignetting is more pronounced, usually when the landscape has few elements, such as large trees or rocks, that obscure the view of the horizon (the source of reflected infrared light waves which cause this effect). With the increased infrared light waves being reflected off of the landscape, the center of the frame, in many instances, will have more density on the negative. The lighting and composition of the shot will determine the severity of this effect.

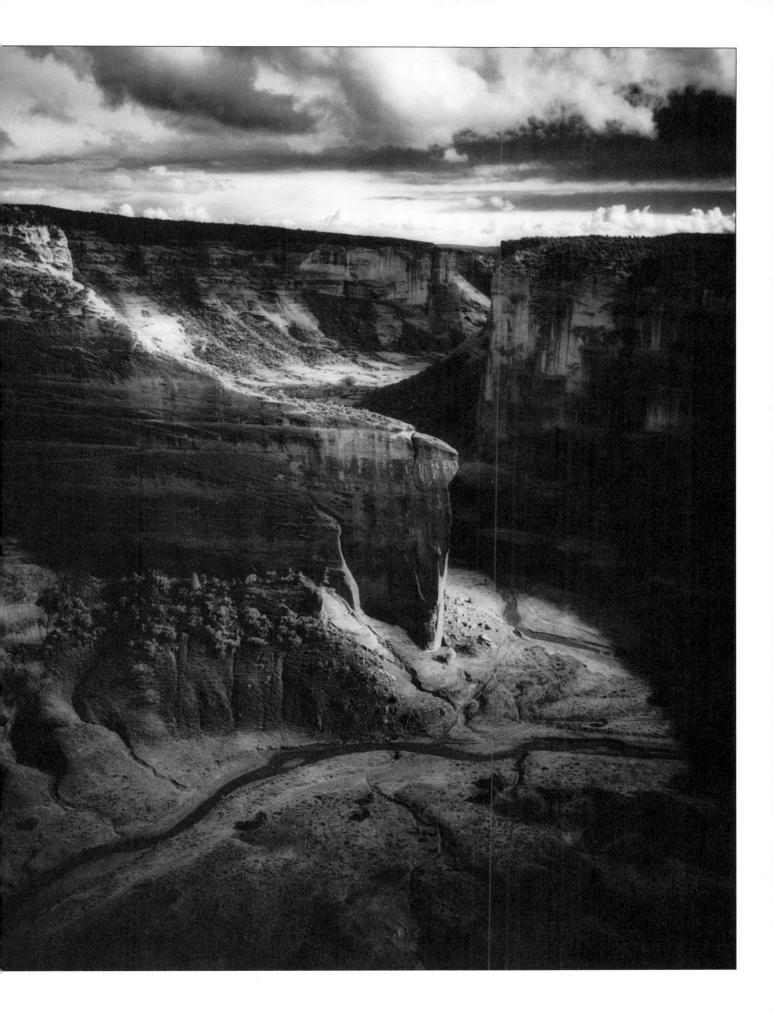

■ Flash & Reflectors

The results of using flash heads with infrared, even underwater flash shots, can be rather interesting. There are certainly times in the field when a flash might provide some extra detail. However, flash can flatten objects and create strange shadow effects I would prefer to avoid. Reflectors offer another lighting option in low light situations and can provide extra shadow detail.

■ Exposure

This is an example of the very high contrast shot you get when shooting into the sun using infrared film. Capturing detail in deep shadows on the subject with a brightly lit sky just above is not what infrared film is designed to do, but I wanted to see how the shapes of the silhouettes translated. Opening up further to capture more shadow detail would have rendered the sky and backdrop unprintable. The fact that infrared film doesn't retain very much shadow detail is something the photographer needs to be aware of before shooting in this type of situation. With this in mind, you may bracket or change the angle of the shot as needed.

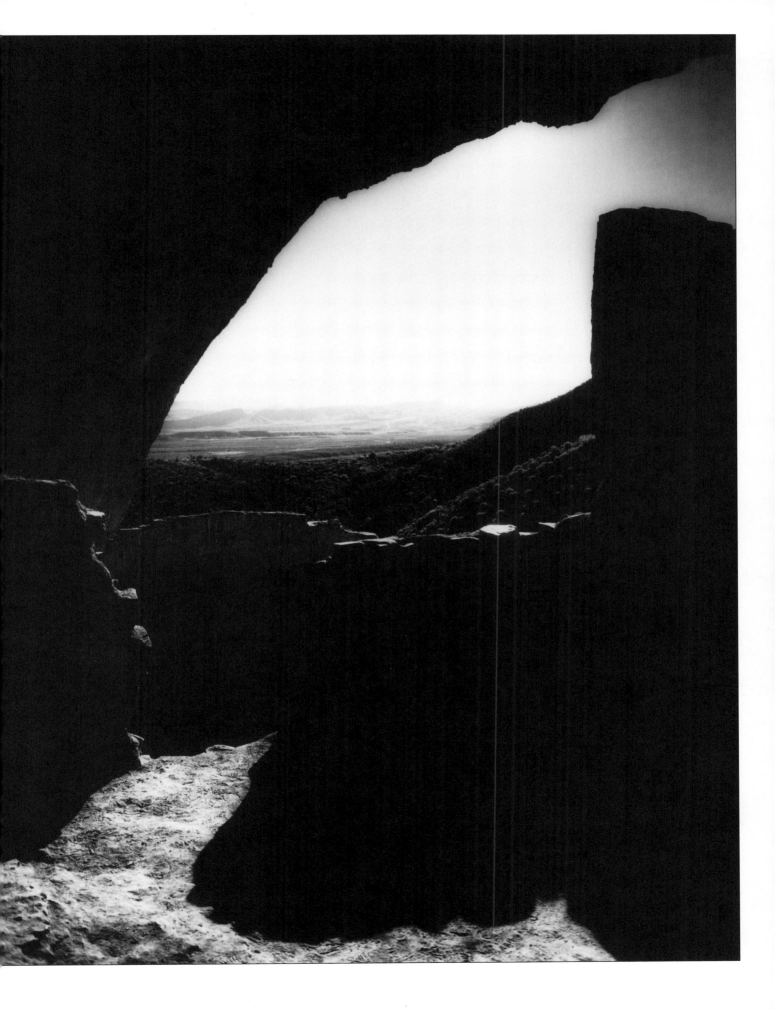

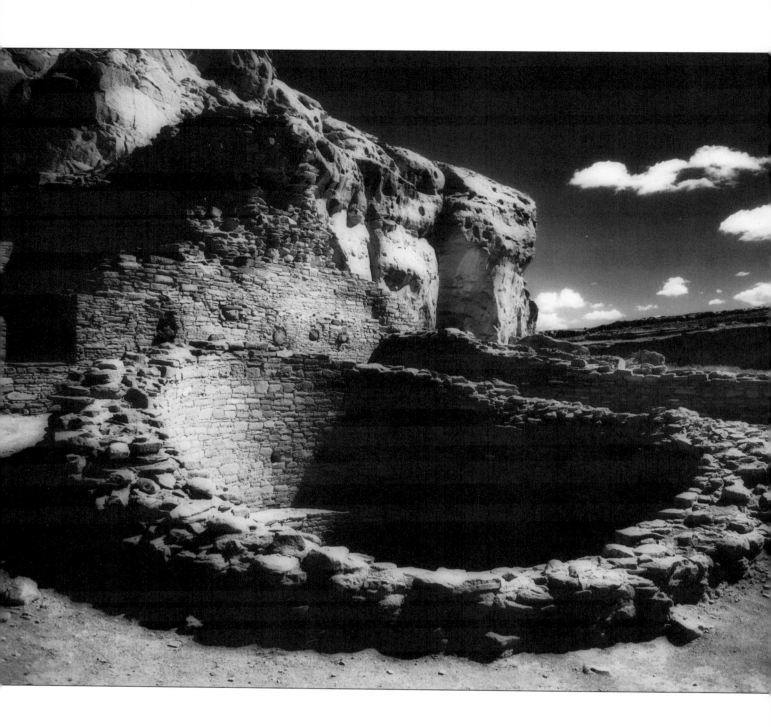

■ Object Color

Images captured with infrared film take on a unique appearance or glow for a couple of reasons, but the most important is the color of the subject. Be it trees, water, or rocks, everything under the sun (literally) either absorbs or reflects infrared waves depending on the object's physical properties and the lighting conditions. For the most part, this is due to the color of the object itself. The black and white infrared films available for still photography are often described as heat sensitive, which may conveniently describe the effect the film creates. However, that description is not altogether accurate. For the sake of keeping this topic from breaking down into scientific formulae, the photographer really only needs to remember that the color of the subject is the most important factor when shooting. Black and white infrared renders colors in shades of gray just as standard black and white films do, but because of the infrared sensitivity the tones tend to be slightly exaggerated. Dark blues go black, light yellows reproduce as white, and so on. Once the photographer gains a sense of familiarity with how infrared reacts to certain colors, lighting situations, and subjects, then the option to delve deeper into the science of how and why these reactions occur can be explored.

■ Texture

Texture also plays a role in reflectivity. For example, a rough surface in direct sunlight will contain many small shadow areas, making it a contrasty element in the image. A smooth, light colored surface efficiently reflects infrared waves which then cause it to reproduce as a brilliant white shape. Foliage, when lit by direct sunlight, will also reproduce as white. However, foliage can also contain many small shadow areas. Shooting infrared in areas where the light is broken up or filtered, such as beneath a group of trees, creates a busy pattern of highlights and shadows. It can also create some interesting shapes, but if the pattern is too busy it may make the image difficult to read.

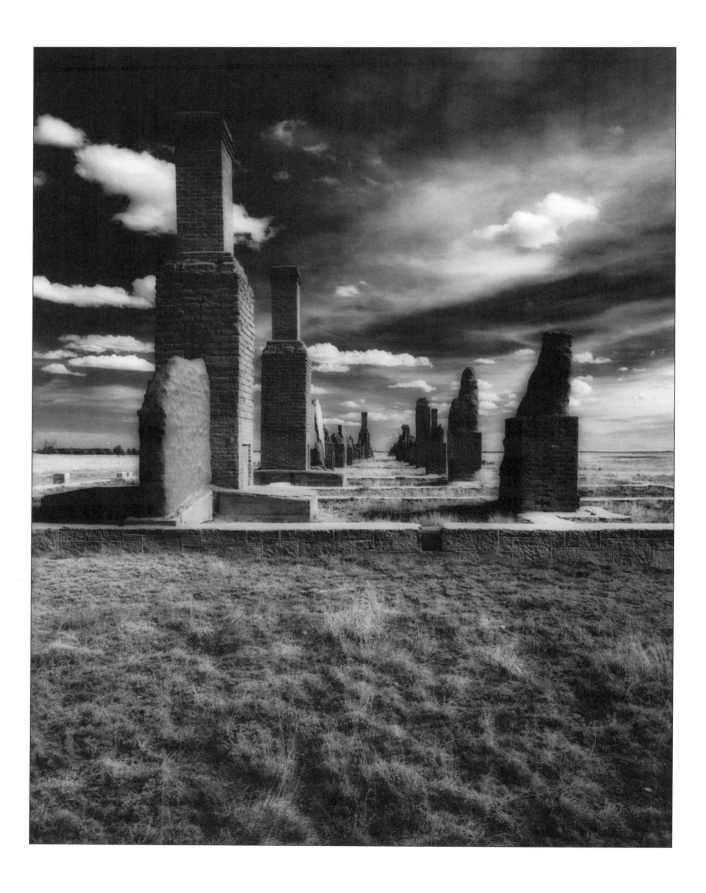

■ Readability

Because infrared film generates images of higher than normal contrast, it can transform an ordinary shot into a strange conglomeration of black and white shapes, making it difficult for the viewer to make sense of the scene. This is what I refer to as unreadable. If the photographer unknowingly captures a scene that the viewer must struggle to make sense of, then the purpose of the shot may be lost. Separation of tones between the elements in a photograph is the key to making the image readable. For instance, had this shot been taken from another angle, say from the shadow side (facing the sun on the right), the black chimneys probably would have blended in with the black sky creating separation problems for the viewer.

■ Composition

Chimneys and foundations lie in rows in the remains of what once formed the officers' quarters at Ft. Union. In setting up the shot, I wanted to capture the depth of the row of chimneys so that it appeared to line the landscape all the way to the horizon. Centering the subject in landscape photography can create images that become stagnant and predictable. This shot is a rare exception to that rule. The base of the nearest chimneys, which are positioned just below the horizon, offset the proportions within the shot just enough to keep the composition interesting.

■ Capturing the Landscape

Merely capturing a scene on film isn't difficult. Composing the scene in an interesting way to greatly enhance its appearance and create a compelling print can be quite difficult indeed. What attracted me to this particular shot was the arrangement of unusual shapes and the oddly shaped opening in the adobe wall. I felt the opening would draw the eye of the viewer into the image. While composing the shot, it was important that I place the camera at an angle that captured objects beyond the wall. I deliberately composed the image so the photograph doesn't completely reveal the shapes on the right and left. This helps to create the sense that the composition extends beyond the edge of the frame. Always take the time to explore with the viewfinder; centering the subject time and time again grows tiresome and predictable. Use the edges and corners of the frame and take full advantage of the image area to help suggest the expanse of a scene.

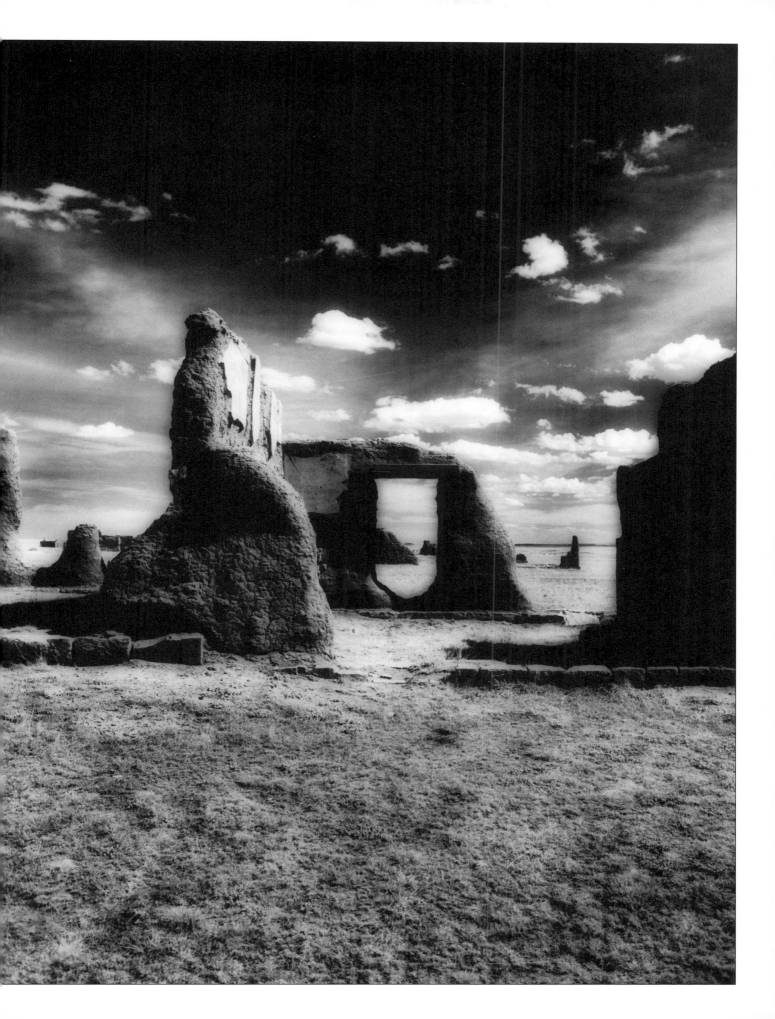

■ Shadow Formation

In framing this shot, I concerned myself primarily with the shape of the shadow. The location was a small room, so once the composition was determined, I was left to make sure the shot was correctly focused and exposed.

■ Readability

There are times when unusual lighting or the simple juxtaposition of objects results in peculiar or unreadable shapes. For instance, in this photograph a bright white door appeared in the lower left corner and created a distraction to the viewer because of its peculiar angle. I corrected this quirky element in the darkroom by intentionally burning it in completely black using a small pen light. This was done purely for aesthetic reasons, but greatly enhanced and simplified the composition.

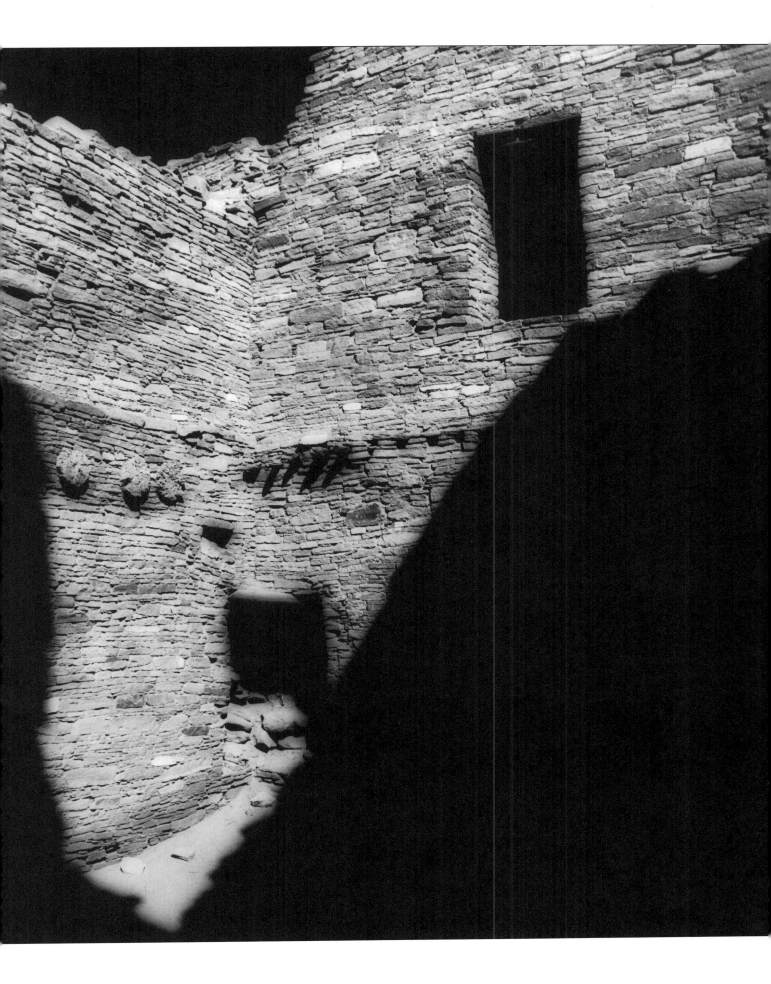

■ Texture

This shot was taken just as the sun was passing from the front of this wall to the back. Because of the low angle of the sun, the texture of the wall is revealed in greater detail. At any other time it would have shown fewer highlights, thereby reducing the undulating texture of the surface of the wall. The arcing of light on the right side of the wall is a typical infrared effect caused by the film picking up the infrared waves beyond the wall. It is an extreme example of the common vignetting effect of infrared, as seen in the image on page 15.

■ Selenium Toning

Selenium toning is a process that adds a reddish, or sometimes reddish blue, color to a black and white print. The single bath process is done after a print is fixed and washed. It can deepen the black tones and in general slightly increase the contrast of the print. This shot is a good example of split toning, which means the print was not toned for the duration of the recommended time. The results of split toning can create an unusual banding effect. This effect usually happens in areas where dark tones fade from black to white, a transition commonly found in areas of the sky. The selenium first affects the darkest areas of the image, deep blacks, although it is very subtle, then the midtones begin to show color. All photographic papers, when selenium toned, reach a point where more time in the toning bath does not increase the effect. This time varies with different papers. The printer has the option of altering the look of the final product by varying the times and dilutions of the toning bath.

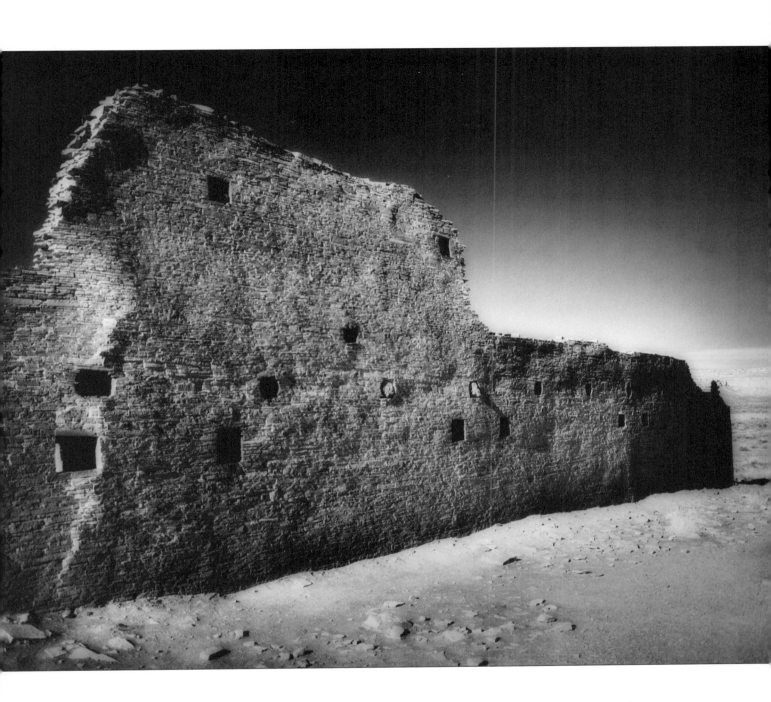

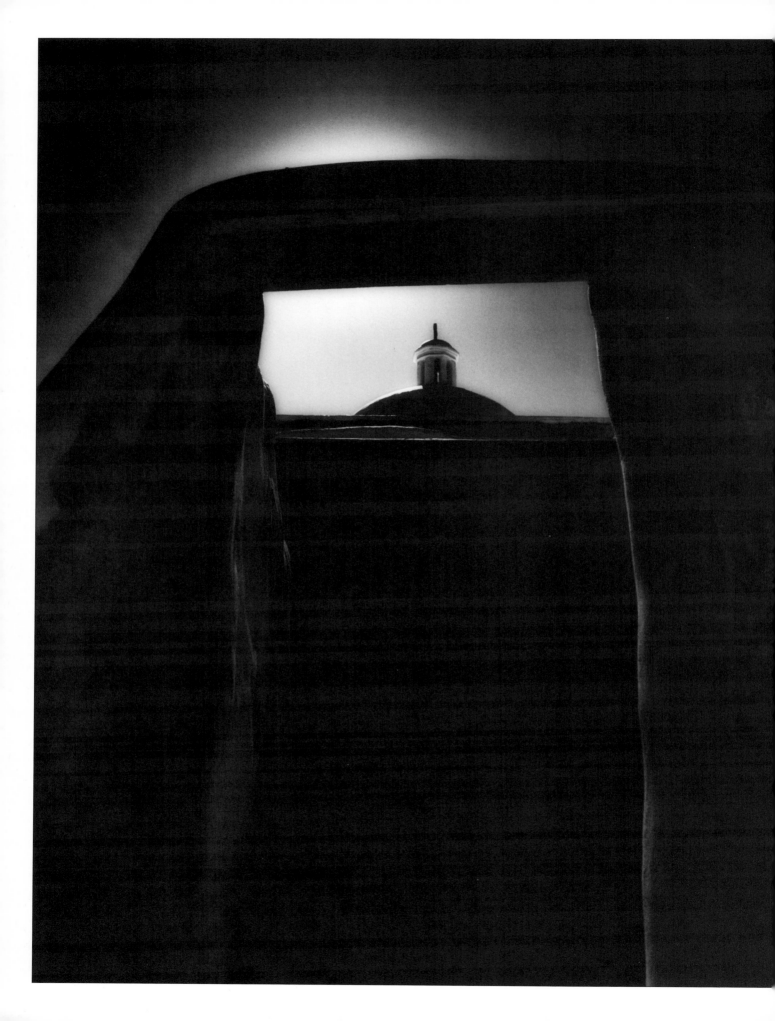

■ Composition

Composition is a broad topic. Personally, I have two approaches or techniques for dealing with composition, and it depends on the type of film I'm shooting – color or black and white. Both color and black and white require different considerations. For someone who has little or no experience with infrared film, I would suggest as a general rule to compose as though it were black and white and expose with the precision of color. A little over or under greatly affects the results. Because Konica and Ilford infrared films are closer, in terms of sensitivity, to standard black and white films than Kodak, compose as if shooting with standard black and white film and pay close attention to the shapes and shadows of the subjects. When it comes time to expose the film, evaluate the tones of the shot, look at how the tones will translate into black and white, thereby increasing the readability of the image. In this shot I wanted to capture the smooth shapes of the doorway with a dramatic arc of sunlight from behind. I was surprised to find the film had retained as much detail as it did, despite being in shadow. Were it not for this detail, had the arch gone black, it certainly would have compromised the composition.

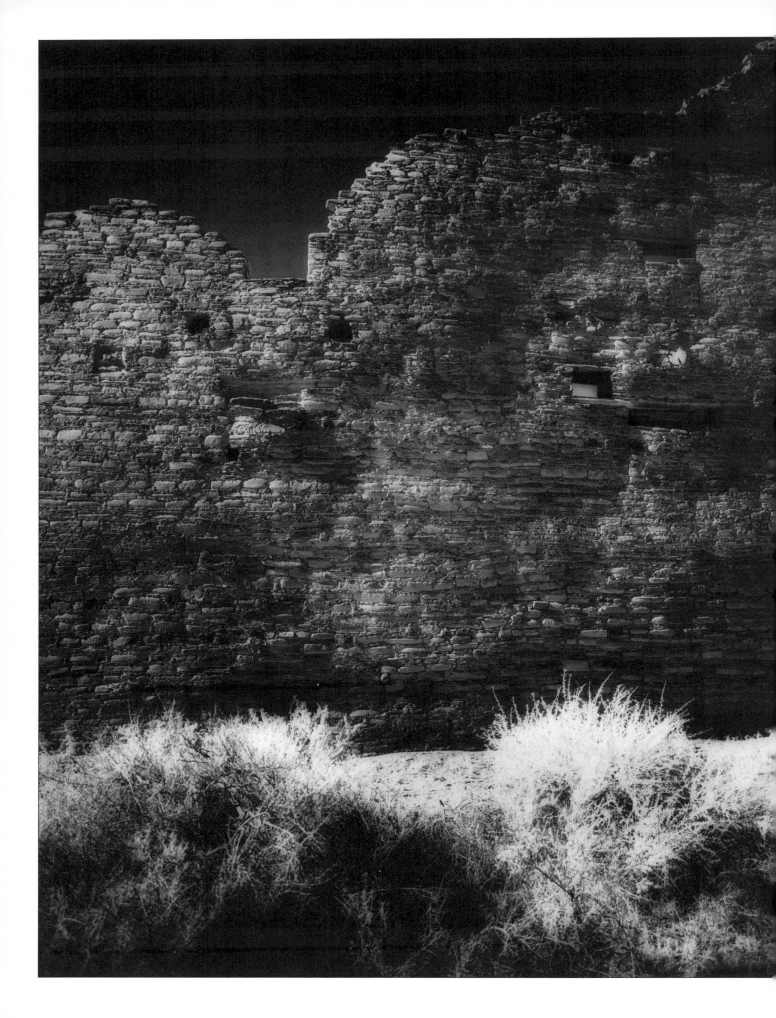

■ Texture

Here I was hoping to capture different textures and present the subject from a more direct angle. The glowing desert scrub, clumped below the wall with its uneven blocks of stone protruding at various degrees, produces a collection of different shapes and tones. The sun was somewhat low in the sky, and it lit the wall from angle that really defined the wavelike surface of the wall. By shooting the wall from this angle, I intentionally flattened the subject in an effort to present the smaller details.

■ Printing

The darkened upper right corner was a concern at the time I shot this, and I managed to bring out enough details in the darkroom by dodging it slightly. The scrub at the base of the wall is also considerably dense in the negative and required substantial burning to bring in some detail. To maintain a full range of tones, it is important to not burn the main source of highlights, in this instance the scrub, too heavily. I could have burned the scrub much more, but this would have reduced them to a uniform shade of gray. Aside from appearing visually unpleasant, this would also eliminate the main source of white or bright highlights in the shot.

■ Exposure

My main concern with this shot was capturing the ruins that lie above, totally in shadow, without completely overexposing the lower half of the image. This difficulty of overexposing certain areas in order to capture other areas was a common problem during the shooting of this series. Many of the sites were cliff dwellings which presented problems with sunlight not reaching the ruins – especially if they were at all recessed from the edge of the hillside. Some of the park sites had printed information available in regard to shooting the sites at various times of the year. Aside from that limited information, the only thing left to do was visit the site early and make the best of it. If necessary, I would then return at a later hour when the position of the sun was more beneficial. Again, the best solution when confronted with difficult or unusual lighting is always bracket two or three shots.

■ Composition

Another decision to make was how to arrange the composition. I chose a vertical orientation, because the upper portion of the setting offered deep shadows and mysterious shapes. These elements give the shot more presence and drama.

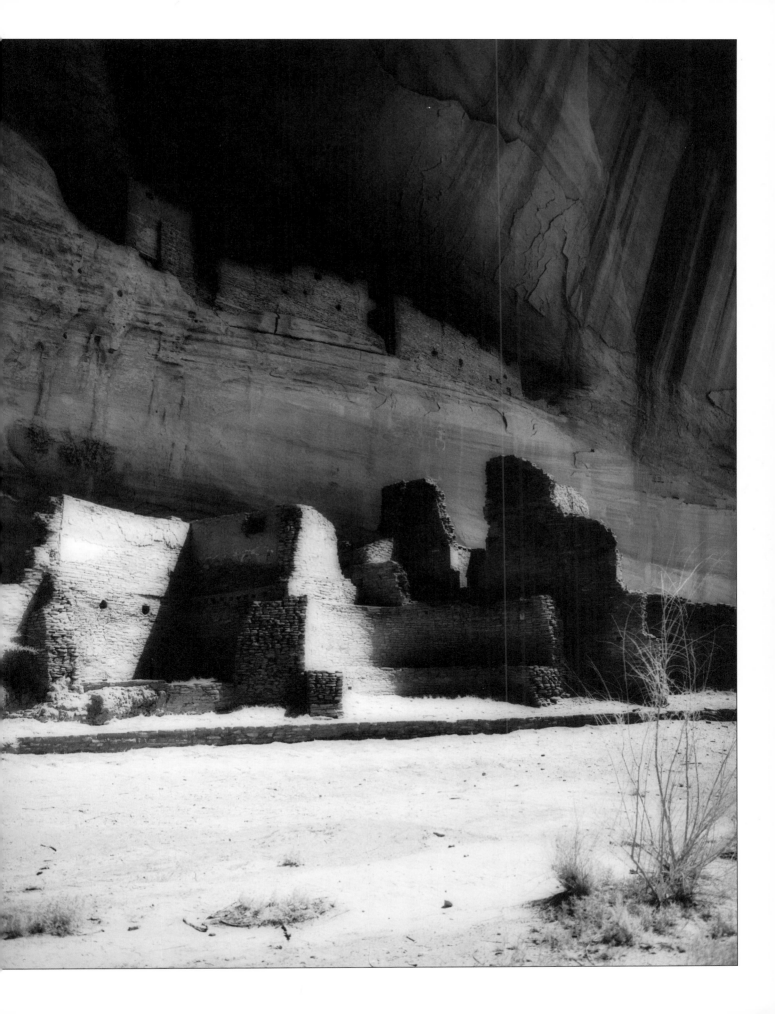

■ Clouds and Sky

Here the problem of cloudy, nearly overcast, skies limited the opportunity for a typically dramatic infrared sky. The sun wasn't totally obscured, and it managed to occasionally penetrate the cloud cover. Those brief moments of greatly needed sunlight offered slightly more contrast to the shots I took. The white cloud cover, although less dramatic, does help to separate the structure from the sky. Still, a sky of broken clouds certainly would have made this a more dramatic shot.

■ Sunlight

Obviously lighting in general is the most critical element when photographing, but unlike standard films that capture images in limited or low light, infrared requires bright sunlight if the photographer is looking for dramatic images. Infrared images captured during overcast days or days with extremely cloudy skies have a very flat and gray appearance. The sunlight is the source of contrast for this film, and without it shadows are greatly weakened and highlights lose their typical infrared glow.

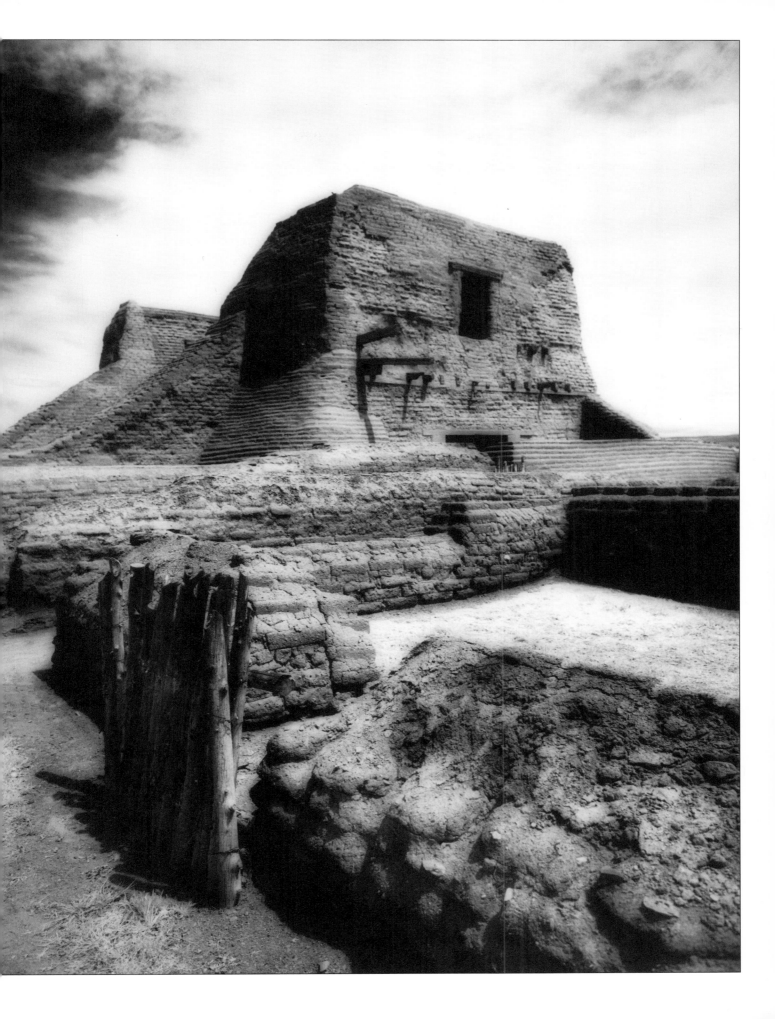

■ Location

This site featured so many unusual shapes that there was always an interesting shot waiting to be found. Located on a wide open grassy plain, City of Rocks could be described as an enormous pile of boulders. Wandering through the park, intrigued by the endless collection of large sculptures, I shot countless rolls looking for that one shot that I knew existed here somewhere.

■ Composition

While I had no problem creating interesting compositions, the shots were spatially compressed and had very little depth due to the close proximity of the boulders. These compositions were reduced to large black shapes that filled the viewfinder and left room for little else. With some distance to work with, I tried to arrange a shot using one of these black shapes in the foreground. Then it became a matter of finding and composing a shot using another interesting element as a backdrop. I concentrated my efforts on the outer edge of this boulder formation, hoping to use this cluster in the foreground. In the distance, another small cluster of rocks provided just the backdrop I was seeking. Ultimately, getting this shot required climbing to the top of some boulders to provide the right angle to capture this composition.

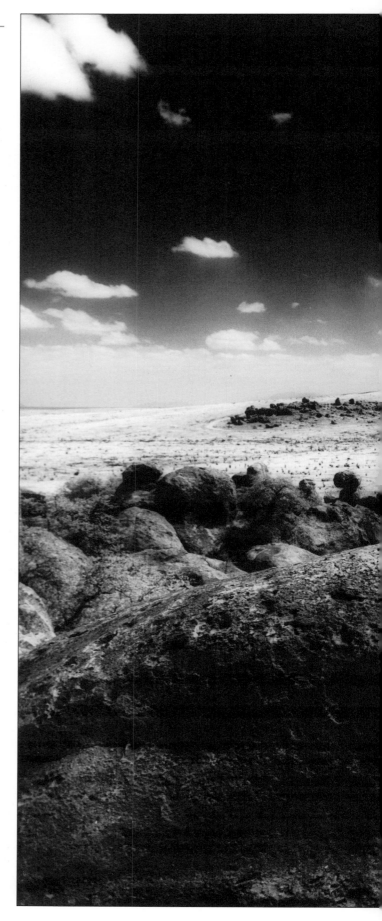

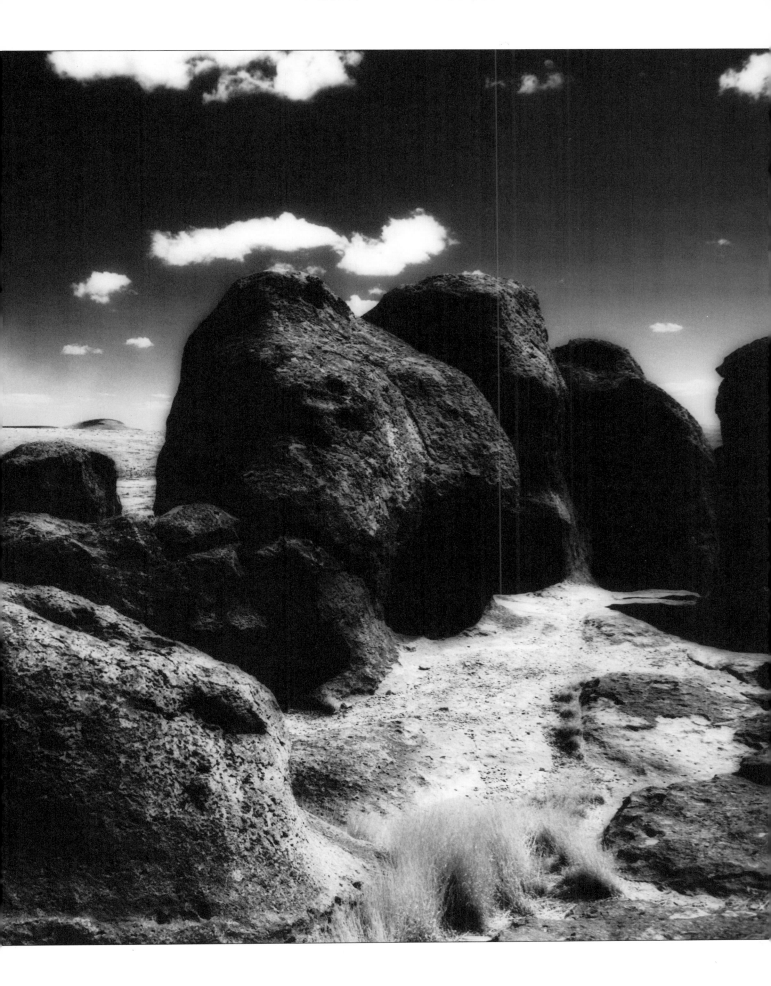

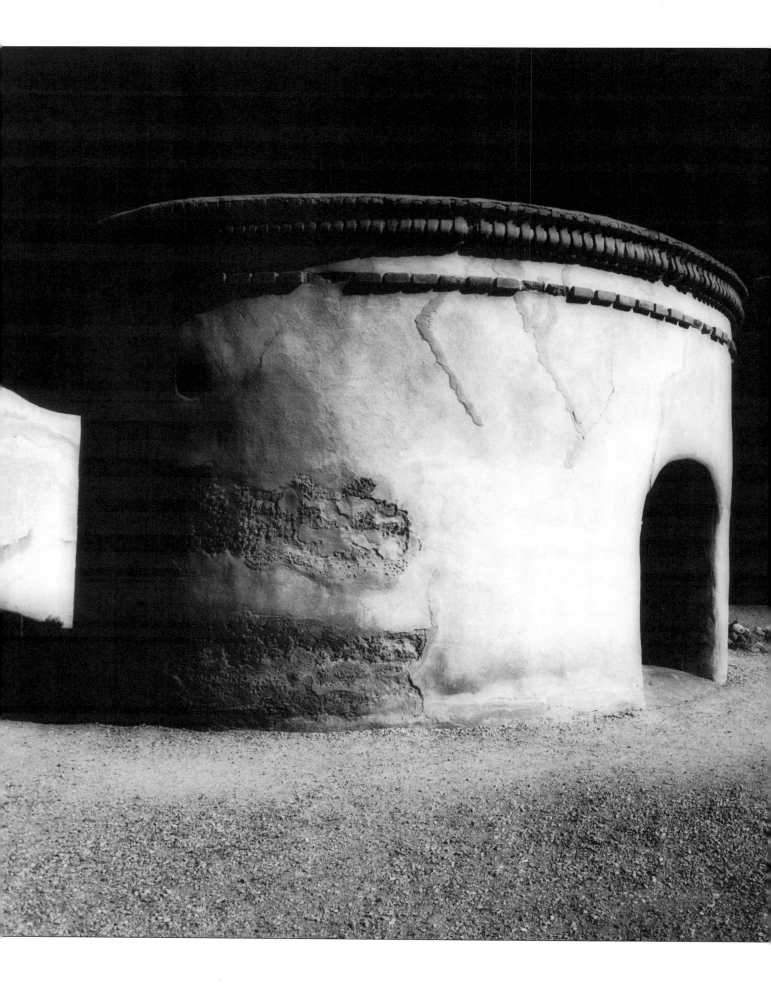

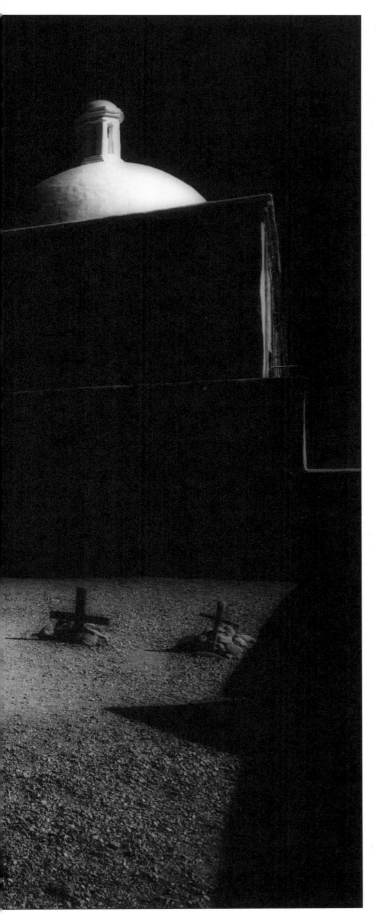

■ Learn from Your Mistakes

When shooting infrared, the photographer needs to take into consideration the way objects separate themselves in terms of both shape and tone. After a few rolls, oversights and miscalculations will become very apparent. Take note of them. Once a familiarity and feel for the film is achieved, mistakes can be avoided by careful evaluation of the results from each roll.

■ Composition

The upper right hand corner of this image pictures an ivory white dome atop a rectangular church. Notice the flat black sky. Clouds would have helped to separate from the sky both the round structure on the left as well as the church. On the other hand, the dark sky allowed me to hide the scaffolding set up for repairs being made on the right hand side of the church. The total darkness of the sky and the iron work blended well to diminish what would have been a distraction. The dark tones of the iron work were further reduced to black in the darkroom. The contrast of infrared can be quite beneficial in allowing the photographer to "hide" objects that happen to fall in the shadows. Many of the sites I visit have people milling about. If they remain in darkened doorways, I often shoot the scene knowing the film will be unable to record them.

■ Composition

I was in the process of leaving this location because the sun was disappearing below the horizon. As I passed this scene, I knew immediately that it would make a great infrared image. The way the highlights of the stone ruin were set against what would appear as a black sky made it an ideal subject. The low angle of the sun produced a very contrasty image; however, I was careful not to stop down because of the limited sunlight. Instead, I opened up to ensure the highlights retained enough detail.

■ Metering

When shooting a scene with limited highlights such as this, it is important that the photographer understands how his/her light meter operates. A general reading of this scene might lead the photographer to believe the exposure doesn't require an additional stop or two more, when in fact it does. Make certain to meter the subject. A scene like this, at this hour of the day, may require an additional stop.

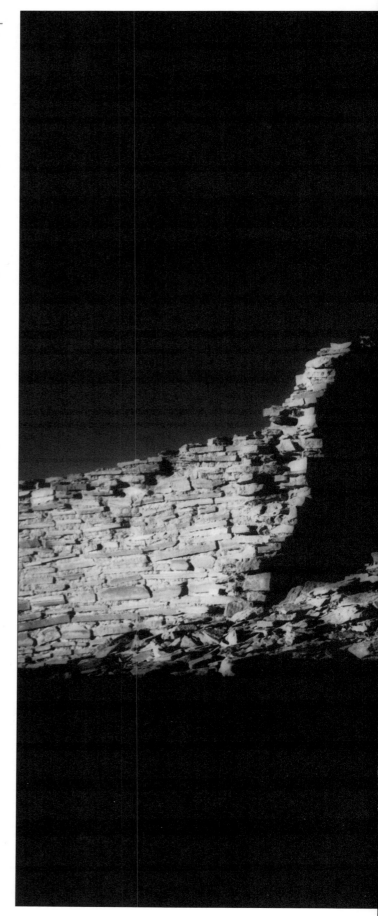

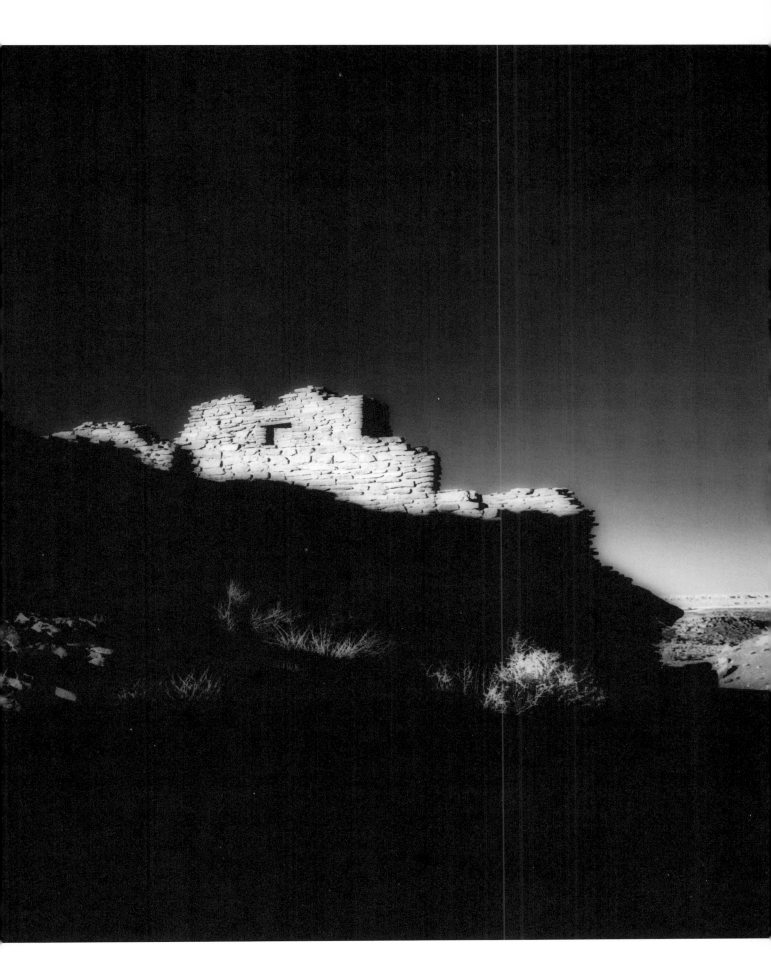

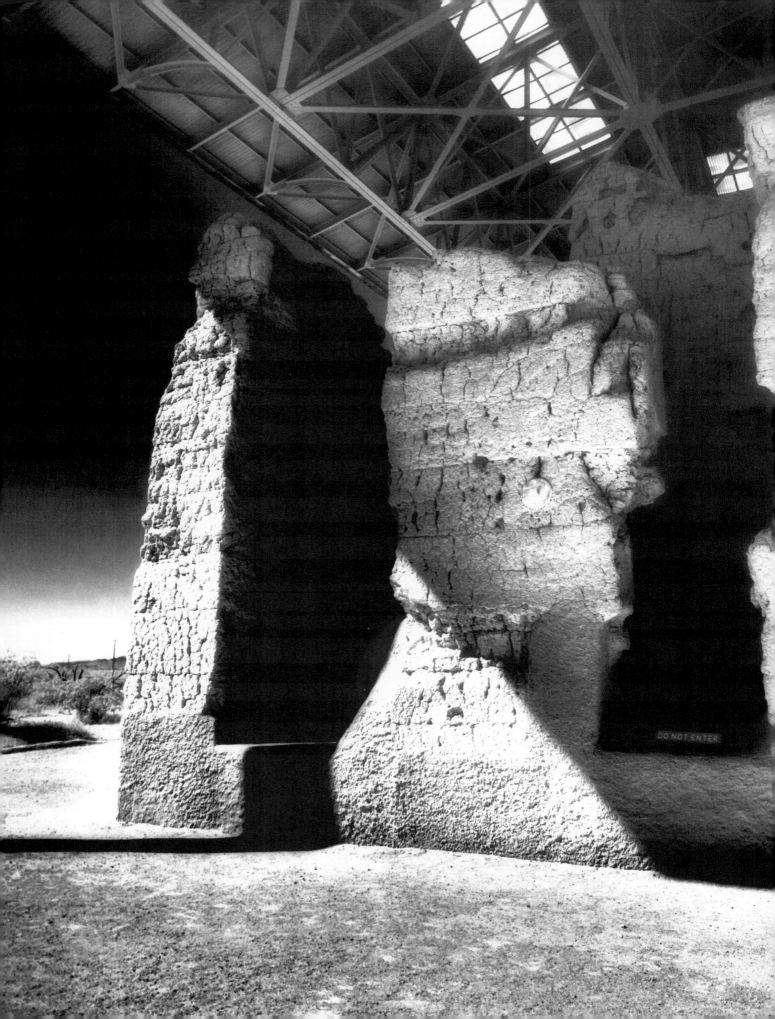

DO NOT ENTER

◼ Old and New

This was a shot that took me completely by surprise. So much of my work has focused on capturing landscapes free of modern technology, that I didn't anticipate shooting this site using the overhead structure with such emphasis. Throughout this series, I wanted to capture various ruins in their natural state, free of modern structures, but there was no getting around it here. So, rather than trying to squeak out a shot of some small fragment of this ruin free of the overhead structure, I composed a shot that captured the structure completely. From a purely aesthetic standpoint, I shot this with the intention of using the colossal hanger-like structure as a means of emphasizing the enormous size of the building. I am quite pleased with how the high-tech structure complements the weathered and worn building. I suppose it is the symbolism of this shot that appeals to me. Because of the lighting, the old worn structure appears to be emerging from the modern truss, as if modern man has somehow failed or become ineffective.

◼ Light

It was clear that the sun was not going to reach a level that would completely light the ruin beneath the covering. So, after unsuccessfully trying to locate something to use in the foreground, I began composing shots from a closer angle. At this angle, I was able to capture just enough of the ruin to give the viewer a sense of its enormous size.

■ Composition

Once an interesting scene is found, first look at how the shadows are arranged. Every shadow, large and small, will translate that shape into absolute black using infrared film. Thinking in those terms will simplify the task of how to compose a shot. When evaluating shots, imagine the shadows as black and take advantage of them. Anyone shooting infrared for the first time might want to take this approach until they've reached a point where they can easily determine whether the available light will provide sufficient detail where needed. The simple composition here presents the scene in a manner the viewer can easily read.

■ In the Darkroom

Images that consist of large objects can make it easier in the darkroom, as dodging and burning larger shapes tend to present less of an obstacle. Certainly there will always be areas within the negative that require burning or dodging. Straight prints are never complete and there is no getting around that. Here the shadow of the building retains some detail, so some dodging was needed to hold that information in the final print.

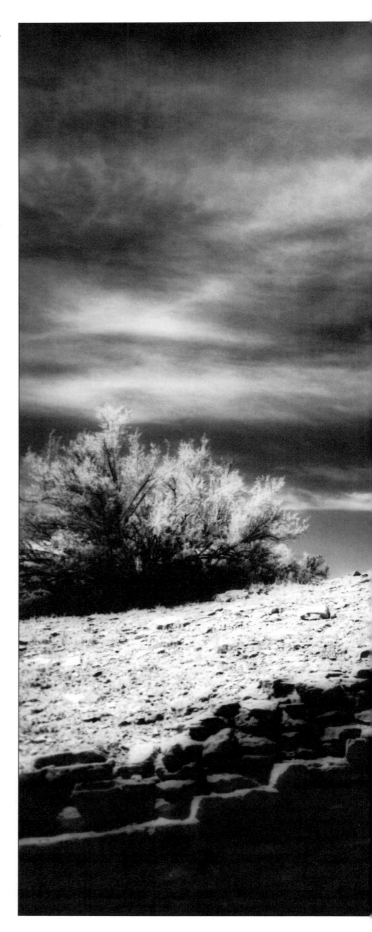

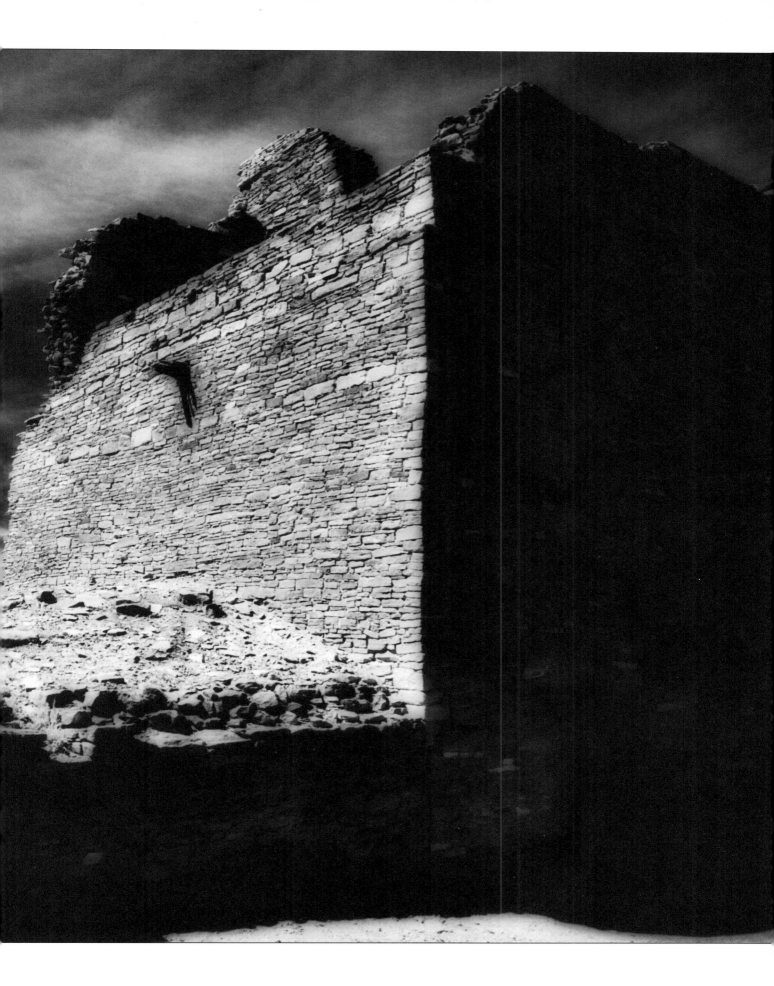

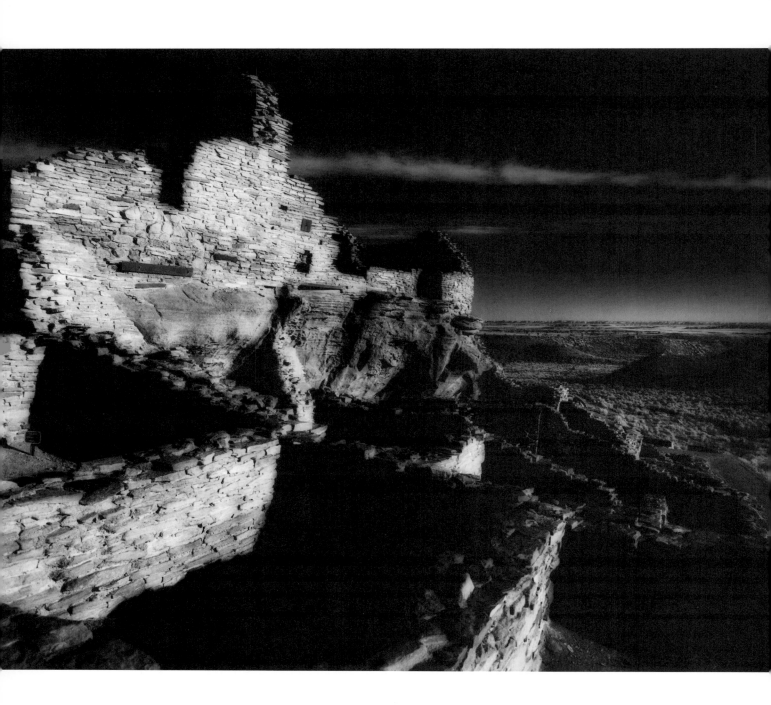

■ Late Day Light

Shooting late in the day, the photographer may end up with an image that is either too contrasty or too dark. Because later in the day there is less sunlight, both direct and reflected, infrared light waves are not as abundant. As a result, shooting later in the day generally requires increased exposure. It is imperative for the photographer to know his equipment. Know how the light meter measures light to ensure an accurate reading, especially late in the day. An inaccurate reading will defeat any efforts to capture a dramatic shot.

■ In the Darkroom

This shot is a bit dark; however, the lightened horizon line (which was something I emphasized in the darkroom with a little dodging) gives the shot some depth. Infrared tends to naturally create this lightened horizon, much like a red sunset on the horizon, only in black and white. I simply emphasized it a bit more.

■ Composition

Just as with standard black and white film, in infrared photography the lighting and composition greatly effect the contrast of any shot. This occurs regardless of which film is being used. When composing a shot, imagine the scene in black and white before exposing film. Those areas that present problems can then be remedied on the spot. Here, because the foreground to the right lies physically a bit lower than the ruins, it had less sunlight. Consequently less detail is visible. The ruins on the left cast long and dark shadows. These shadows aren't necessarily good or bad; they are just an element the photographer needs to be aware of. They can be a problem if they envelop an important element within the shot, or if they break up the composition too much. While composing this shot, I was uncertain whether the center area, with its small sections of shadows, would create an area that was difficult to read. Because of the high contrast nature of infrared film, I have developed a method of composing that is based on simplifying the composition. This reduces the potential for problems with the shadows and separation of the elements within the image. Here I was concerned that the many small portions of the building would create a maze of shadows and create a busy image. In the final product, I don't see a composition overly complicated with small shadows.

■ Sun Angle

When I've found an area or subject that I find intriguing, I begin by observing the position of the sun and how the shadows fall. If the sun is high in the sky, creating short and limited shadows, the resulting photos will probably appear to be rather flat. In many instances, it's best to shoot with the sun at a forty-five degree angle from the subject. In this way, the subject will present both strong highlights and shadows to define its shape. The best shot is seldom taken with the sun directly behind the photographer. This will flatten and greatly reduce the shadows.

■ A Gradated Sky

The situation presented in this shot is an exception to the rule. The sun was relatively high, but that was something I could use to my advantage. Instead of waiting for the sun to move to a lower position, I chose to shoot the building and the roof as a silhouette. This approach presented two problems. The first was how to create separation between the structure, which would translate as black, and a sky that would also reproduce as black because of the lack of clouds. Fortunately, when shooting a relatively clear horizon that is mainly unobstructed, infrared film tends to produce a gradated sky, black on the top and white on the horizon.

■ The Foreground

Another obstacle was composing this image using a foreground that possessed some interesting shapes other than the widely available scrub. Desert scrub can be picturesque, but I prefer and tend to look for the unusual. Here, the eroding walls that surrounded the structure provided both highlights and shadows, as well as some interesting shapes.

■ Composition

With my location selected, I compose through the viewfinder. As I look through the viewfinder, I pay special attention to the corners of the frame, eliminating not only such things as half-cropped shrubs and signs but also people, cars and modern devices in general. When I shoot a landscape, I want the viewer to see the landscape. Finally, after all this has been dealt with, getting the shot is just a matter of getting the correct exposure. In this situation, a simple bracket of one or two stops should produce a printable negative.

■ People

I remember years ago reading about a stock photographer whose work consisted of outdoor shots, hikers, bicyclists. A comment made about his work has always stuck in my mind. It stated that any shot with a human figure in it immediately places the focus or importance of the shot on that human figure. The statement is entirely accurate. For as long as I've been shooting landscapes, I've made a conscious effort to keep people out of my images for just that reason. A human figure in a shot becomes the subject of that shot, and I feel like the same holds true for any modern human devices such as cars or airplanes. Not to mention it also dates the image.

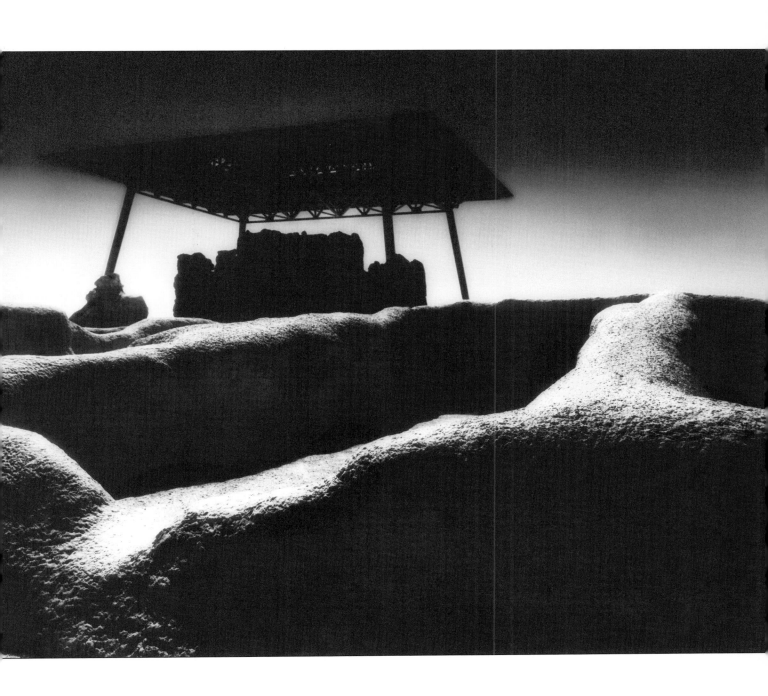

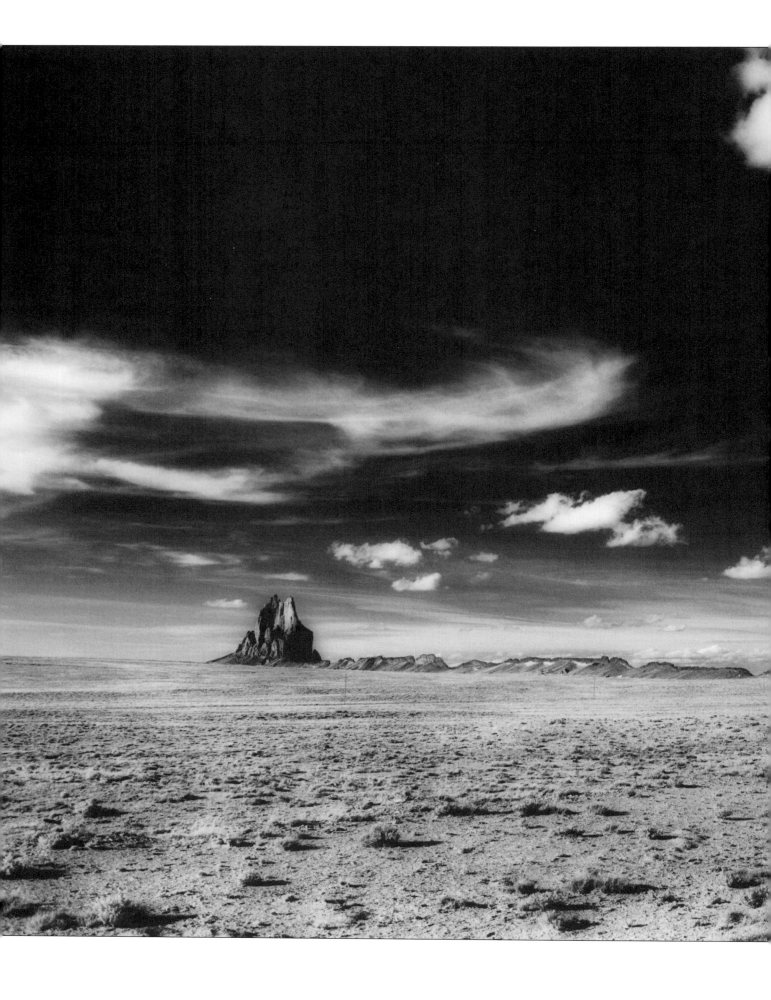

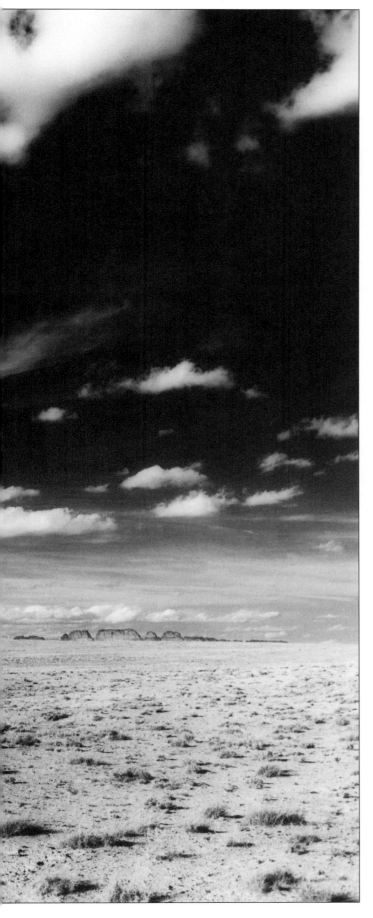

■ Sun Angle

I chose to compose this scene with a little more surrounding space than I typically include. This was a personal decision based on the fact that so many of the shots in this series are located and arranged in very tight formations, often in small caves. I thought I should take advantage of this open space.

■ Wide Angle

I always shoot with a wide angle lens so it doesn't require a great deal of distance to achieve a very wide effect. I have always preferred a wide angle simply because it captures as much of the scene as possible without excessive distortion. Here, the space it allows me to depict suggests the vast open expanse that typifies this location.

■ In the Darkroom

With the darkened sky and midtone of the foreground, I was certain I would get a dramatic shot of an unusual rock formation that would have a genuine Southwest feel. The only obstacle I encountered in the darkroom was the uneven foreground. During mid-day hours, infrared typically creates a hot spot in the center of the image and leaves the corners slightly darker. When the sun is in a lower position in the sky, that hot spot may appear on either side of the shot depending on the position of the sun. Remember, it is the infrared light waves the film is sensitive to, and these waves are also reflected by the landscape. Because the rock formation and sky were rather evenly exposed, in the darkroom I simply evened out the foreground with some additional burning on the left side of the image.

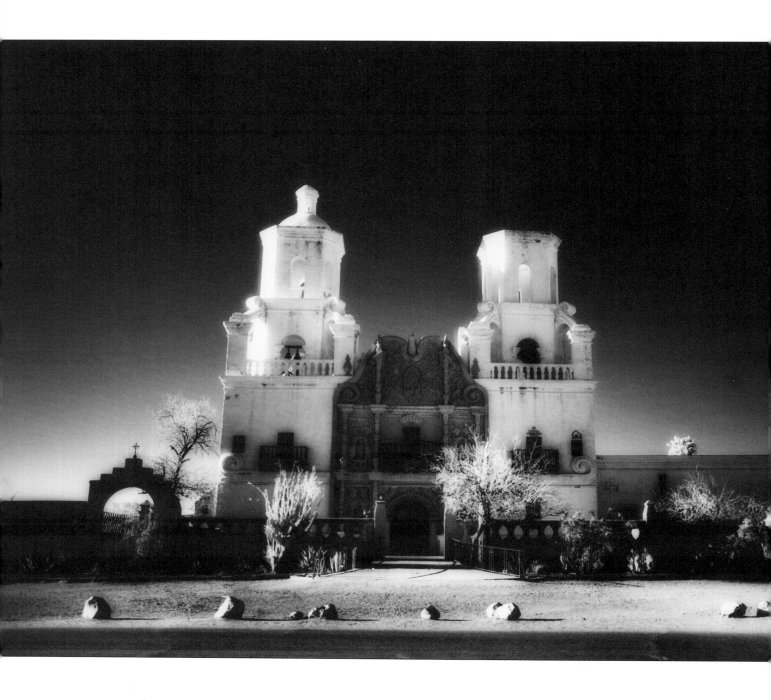

■ Lighting

There will be times when the lighting just doesn't allow the photographer a lot of options. Short of returning later in the year when the sun is better positioned, you will have to make the best shot with what is available that day. Here I had hoped to get a better shot of this scene early in the morning, capturing a dramatic sunrise with the sun low in the sky or maybe directly behind the Mission, possibly creating some unusual backlighting. But the light of the sunrise was obscured by a nearby hill. The backside of the Mission didn't offer much in way of shapes or stonework. Clearly, the facade in the front was visually the most interesting. So at this point, I was content to take the obvious shot, and I'm satisfied with the final results.

■ Eye vs. Camera

Photographers in their early years must all go through the process of learning how what the human eye sees translates into a photograph. This process is quite similar to the darkroom process of learning how light affects photographic paper. Both of these possess that element of fascination with how one affects the other. That's the lure of photography in its earliest stages. As expected, the only method of learning this comes from practice, repetition and experience. If this is unfamiliar territory, take advantage of the freedom that comes with being new by experimenting. Try photographing using angles and lighting that you might not usually try and study the results. This will provide a better understanding of how the film reacts under these circumstances and make it possible to anticipate these results in the future.

■ Tonalities

When taking this shot, I knew I was dealing with a rather monochromatic subject that would result in an image with limited tonal range. While I'm pleased with the softened rendered look of the canyon walls, I was hoping for brighter highlights.

■ Exposure

Increasing the exposure would have given the the negative more density, but that doesn't increase the contrast of the available lighting and probably wouldn't have produced a desirable negative. Several factors contributed to the limited tonal range found in this shot. First, the lighting was very poor. The ruin is located beneath the canyon wall, lying in the shade. To make matters worse, the sky was quite hazy, which reduces the intensity of the contrast both in the highlights and shadows. The subject matter itself was also a factor, as both the canyon walls and the ruin consisted of the same reddish stone. I felt all these factors combined would not yield a useable negative. However, I was quite surprised with the final results even though a higher than usual grade of contrast was needed.

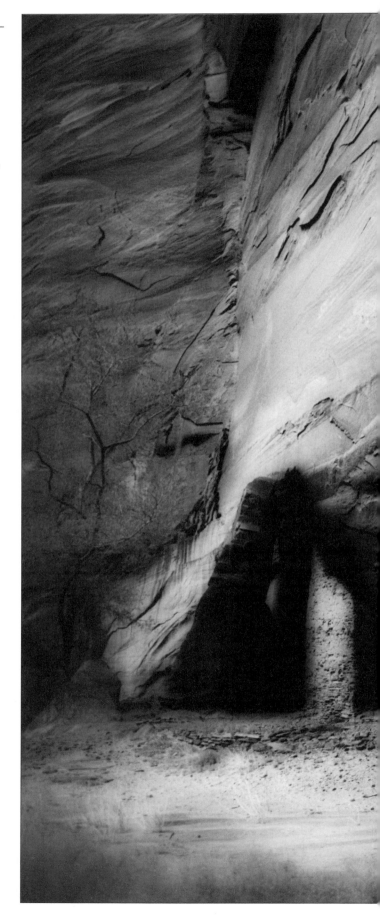

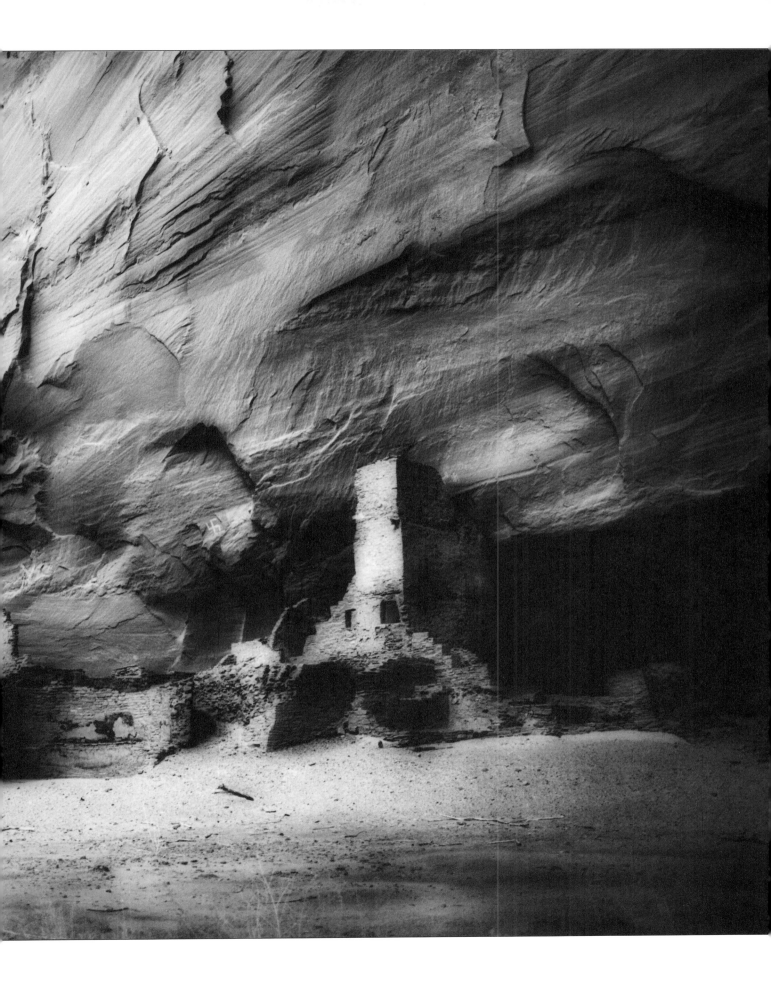

■ Experimentation

This shot was purely an experiment to see how well these carved features would translate in infrared. I was curious as to whether the film possessed the sensitivity to generate sufficient tones to define the shapes carved in the rock.

■ Sun Angle

These petroglyphs were on the shadow side of the stone at the time the shot was taken. I fully expected the best shot, or best exposure rather, would be available at a later hour when the sun angle provided direct lighting onto the petroglyphs. What I had working in my favor was the fact that this stone, which may or may not be apparent in the shot, had a black surface which when scratched or carved revealed a lighter stone beneath. So in this instance, the lighter color of the stone beneath the surface seems to have allowed the film to capture these petroglyphs quite successfully. This shot demonstrates the importance of color when shooting with infrared film.

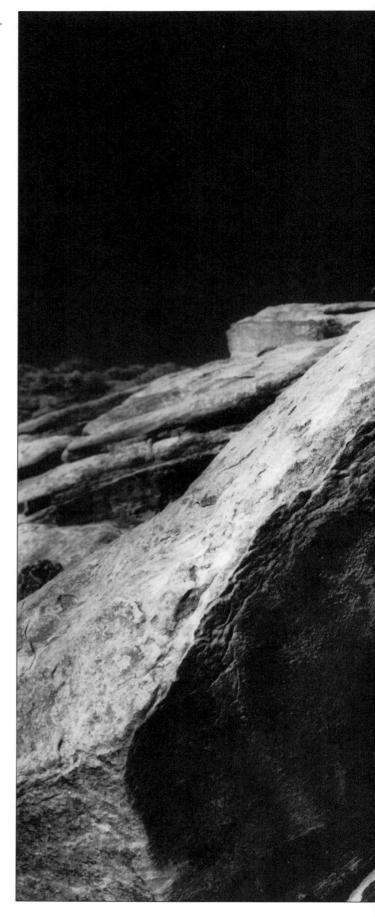

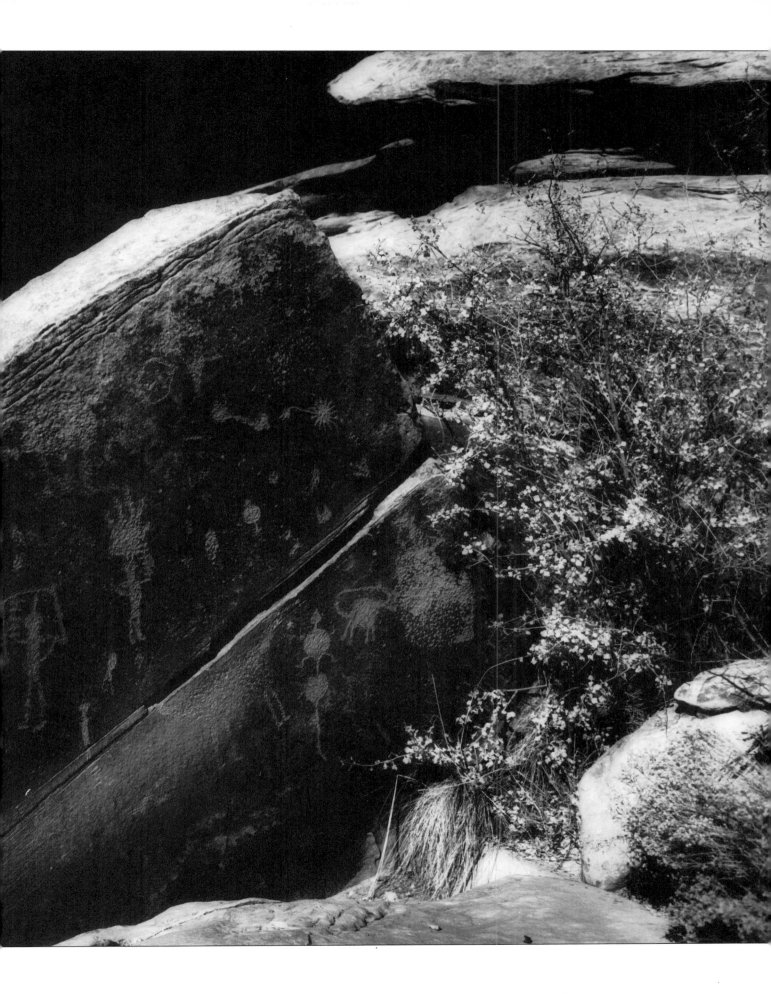

■ Lighting

Occasionally I experiment with lighting. This
helps me get a better understanding of how
the film reacts to unusual situations. This ruin
is located on the ledge of a cave where the
lighting was direct and reduced to a shaft of
bright light that entered the opening of the
cave. There was no getting around the fact that
the final product was going to be contrasty.
The harsh, limited lighting created an absence
of reflected light which would have helped
define the surrounding shapes. The building
was positioned perpendicular to the light
source so the walls facing the sun were very
bright, leaving the others in complete shadow.

■ Lighting Accessories

This would be an ideal situation to try a flash,
or possibly even a reflector, to add some side
lighting. These small tools can occasionally
make a big difference when confronted with a
situation such as this. The lack of depth and
shadow detail doesn't necessarily work against
the image, but the use of a flash or reflector
could provide some much needed detail in the
deep shadows.

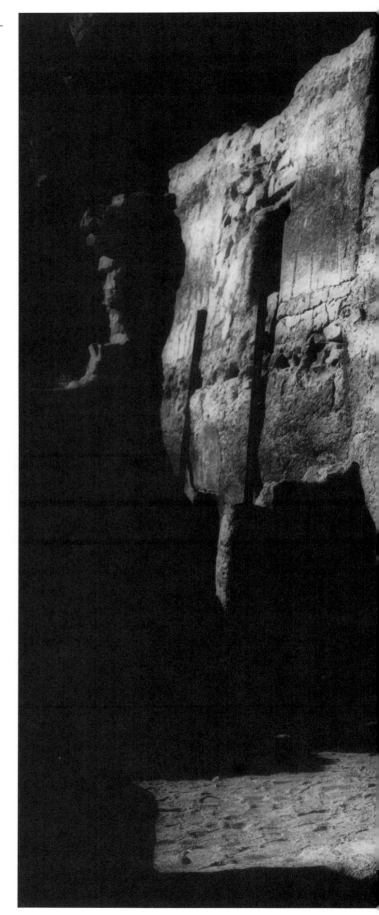

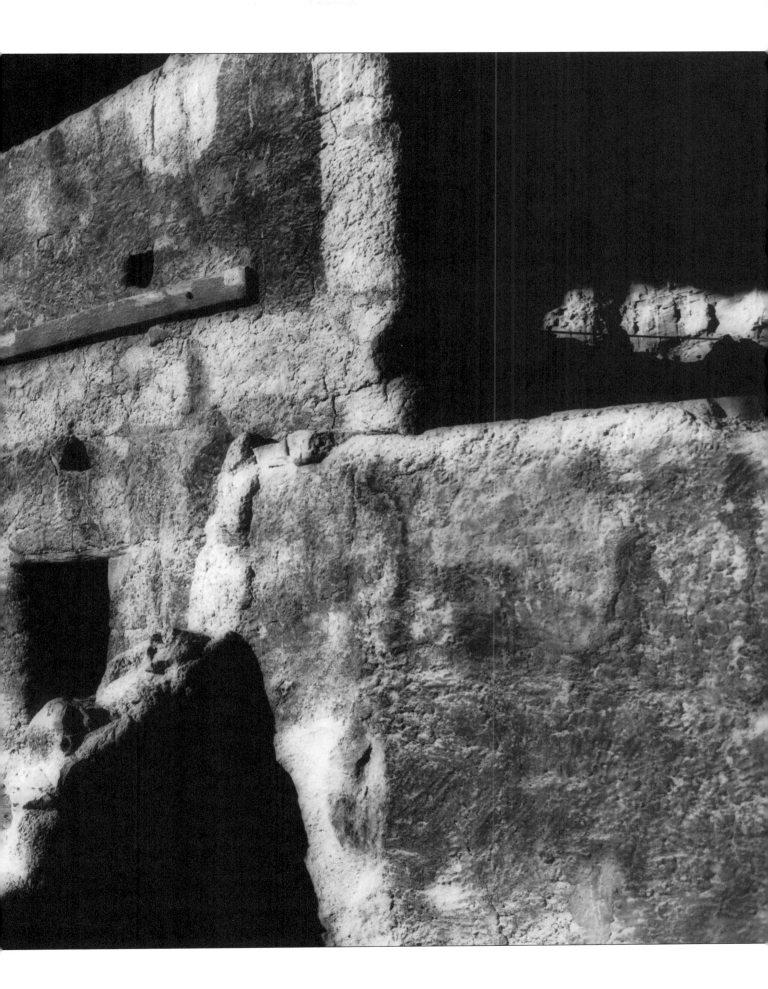

■ Experimentation

This shot was taken from the interior of the ruin. I composed it at an angle that was intended to use the dark shadow in the foreground as something of a base or foundation for the final image. I was trying for the same effect that I achieved with the image on page 40. Here, however, the lighting was a little different, and the results weren't quite as dramatic.

■ Lenses and View Angle

After years of shooting, experimenting with various lenses in countless different situations, I found that I tended to use my wide angle lens (a 28mm lens on a 35mm camera format) for a majority of the shots I liked. What I find appealing is the range or distance a wide angle captures. This extra wide negative presents the subject as human vision sees it, from side to side. All of this shouldn't leave anyone with the impression that normal or longer lenses are less useful or inferior by any means. My personal approach is to present the subject in a manner that resembles the actual situation, using a film that enhances the experience. Longer lenses tend to spatially compress objects, which creates a different set of variables. Using a long lens creates a different type of distortion, as shapes become exaggerated in size. Objects in the distance become larger as the focal length of the lens increases. This is how large moons are created in cityscapes shot at night. Using a longer lens with infrared doesn't introduce any new variables that wouldn't normally exist (although it may increase the appearance of vignetting). However, keep in mind that as a lens' focal length increases, the speed decreases – and infrared film is already quite slow.

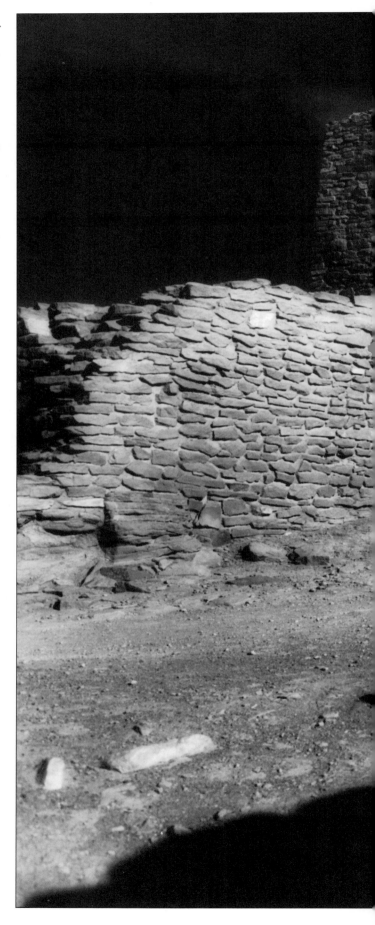

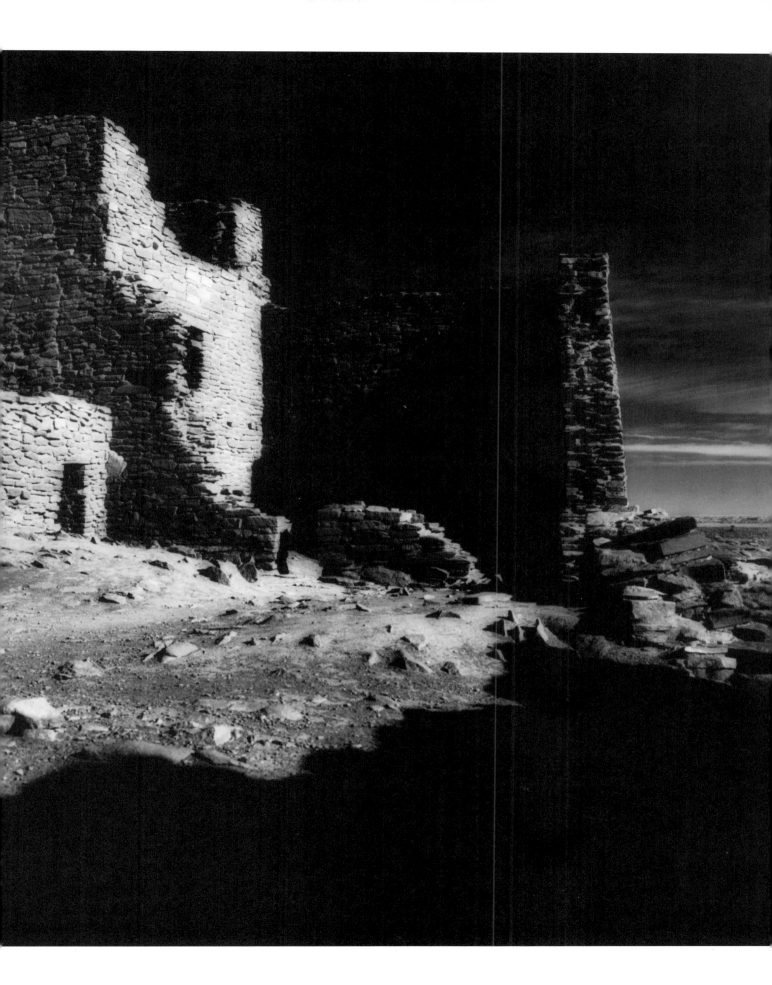

■ Experimentation

The initial element that appealed to me in this shot was the strong diagonal line of the concrete foundation in the lower portion of the photo. I wanted to shoot this at an angle and maintain it as a diagonal element because objects in landscape photography tend to have either a horizontal or vertical orientation. As I'm searching for a shot, I always keep an eye out for unusual shapes – and objects with diagonal lines tend to be quite unusual. If I had aligned the image on the axis of the foundation, the straight edges would have rendered a more typical, and less interesting, horizontal or vertical composition.

■ Sun Position

The position of the sun worked to my advantage in a couple of ways for this shot. The darkened backsides of the chimneys help to separate them from the sky. The minimal detail in the shadows strengthens this separation. The shadow formation also gave the shot a bit more drama and contrast. With the sun behind the photographer, those shadows would be virtually eliminated.

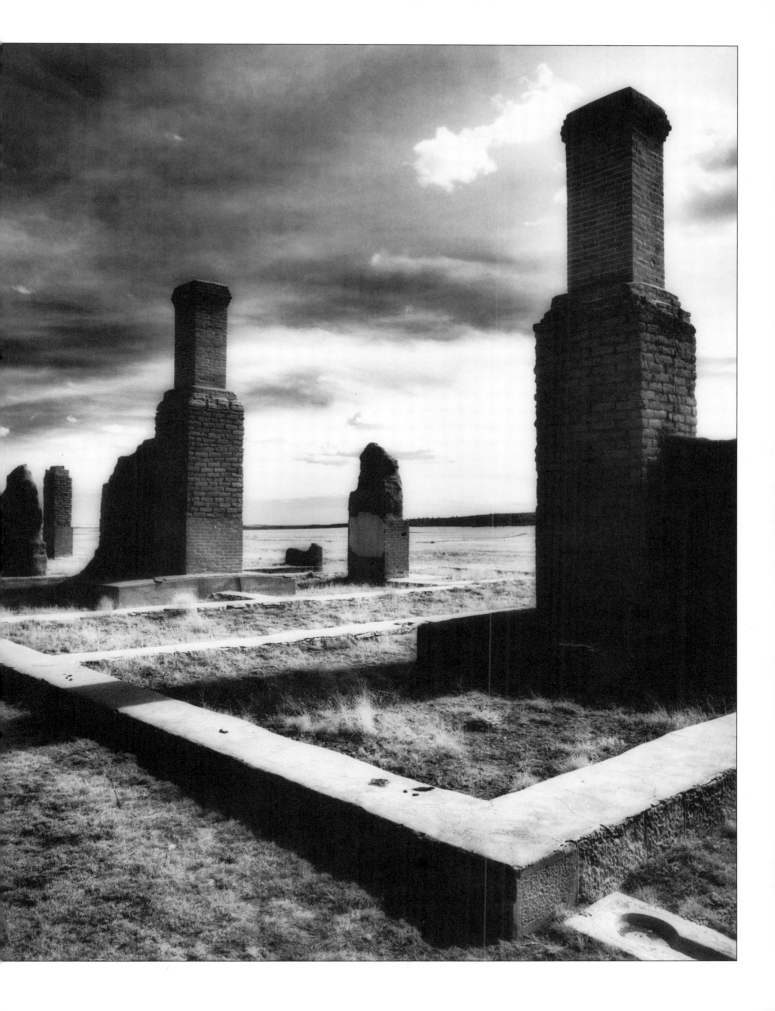

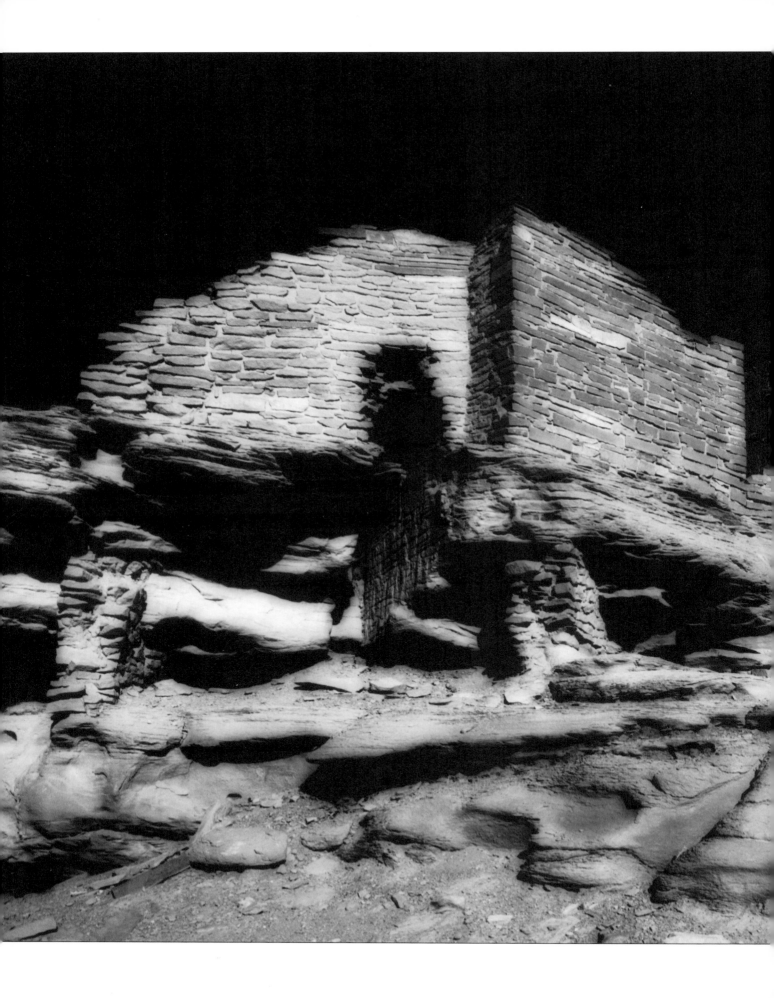

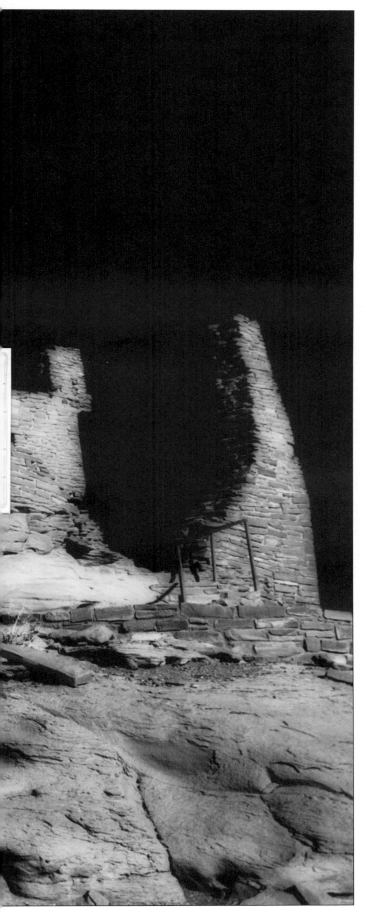

■ The Sun at Your Back

The angle of this shot appealed to me, with the strong facade of the ruin standing above the viewer. Knowing the sun at my back would create problems by reducing the definition of the shapes, I composed the shot using the rocks in the foreground to compensate for this lack of shadow area. I had hoped that these shapes and shadows would add something to the shot. Yet, a close look at this image reveals a lack of definition in the shapes. The entire subject has a very frontal, almost two dimensional appearance. Even though this site doesn't have the restricted lighting that exists in the shot on page 58-59, the angle of the sun relative to the photographer is similar. Adding to the flatness of the lighting was a sky completely free of clouds, which would have added some much needed dimension and atmosphere to the shot. This shot serves as an example of what to expect in terms of definition when shooting with the sun at your back.

■ Sun Angle

In general, make sure the sun is at an angle that will produce strong shadows, or look for a backlighting situation in the scene. Make the most of what is available, and if nothing strikes you, take the time to experiment.

■ A Routine

I know from my own experiences that I have a routine by which I approach a shot. There's nothing wrong with that, if the final results are solid. It is important, however, to be aware of this in order to keep the images fresh and original, and to keep your work from growing stagnant.

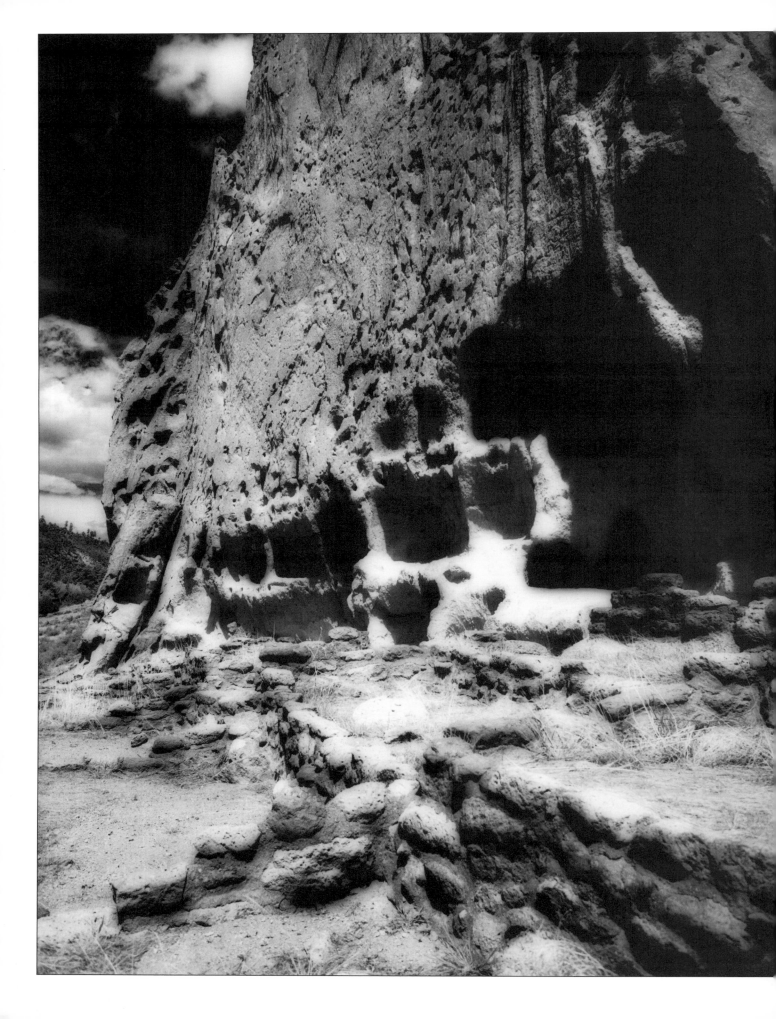

■ Obstacles

The overriding limitation of this shot was simply the location. The area was quite populated with tourists. For my style of shooting, this meant some extra patience and resourceful cropping.

■ Texture

The carved appearance of the stone at the base of this wall provided some interesting shapes in this shot.

■ Exposure and Bracketing

Two basic technical aspects to photography that are taken for granted or misunderstood have to do with exposing film. Cameras today offer so many automatic features that the photographer has been denied many of the creative elements inherent to the art of photography. It is important to anyone with an interest in getting as much out of their work as possible to understand how their equipment operates. The first point to make in regard to infrared film is understanding the light meter. Know how it reads light, and learn how to interpret this information. Because of the contrasty nature of infrared film, if the exposure is off even slightly, highlights could be rendered unprintable, or shadow detail nonexistent.

Standard black and white film is much more forgiving, and a stop either over or under is usually something that can be remedied with a certain degree of success during printing. With infrared, a stop over or under will often be enough to render the shot worthless. Knowing the equipment will eliminate a vast majority of these problems, and the rest can be saved by bracketing. Making consistently good exposures takes some experience. Don't hesitate to bracket if there's any question about a shot. Remember, film is cheap, but your time isn't. After you've captured that spectacular shot and the praise is being heaped upon you, not only will nobody ask if you bracketed, nobody will care! Getting the shot is absolutely everything. Another point to make about all infrared films in general is that when the exposure is increased, the more extreme the glow of the infrared becomes. Stopping down will not only darken the image and reduce detail, it will also reduce the glow. Because Konica and SFX don't possess the sensitivity of the Kodak infrared, reducing the amount of infrared waves reaching these films will affect them to a greater degree and therefor effect the dramatic appearance of prints made from these films. This can create an image similar to that which standard black and white film produces.

■ Composition

While on a tour through the canyon floor, which was quite incredible both in terms of the scenery and the stories told by the guide, the weather went from warm sun to light snow in a matter of minutes. It was late spring, so changes in the weather were not unusual. Here as we were passing through the stream, I wanted to capture a distant highlight on the canyon wall as it reflected in the stream. The sky was quite cloudy and dramatic and promised to add a little punch to the scene.

■ Dimension and Motion

Dimension with infrared is something I make numerous references to throughout the book because I feel it is a critical element when using this film. More often than not, references made to dimension relate to the lighting in the shot, for that is in large part what creates depth in a shot. Dimension also refers to how the photographer presents the subject, as something that possesses volume or flattening the subject with a narrow depth of field. Both of these are elements the photographer needs to be aware of and take advantage of to make the most of each shot. Motion can play an interesting role, as either a slight blur or as swirling lines, by using a longer exposure. Because the film is so slow, it wouldn't be difficult to create motion using infrared film and may very well create some extremely interesting shapes and lines. Also, the combination of using a flash with a longer exposure creates some interesting shapes.

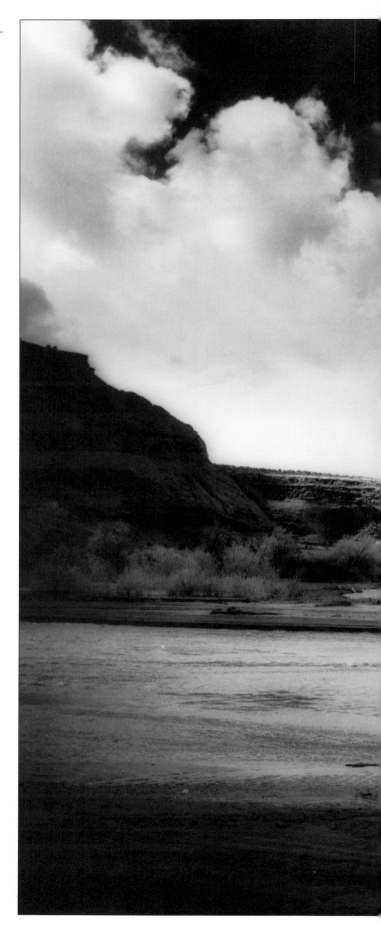

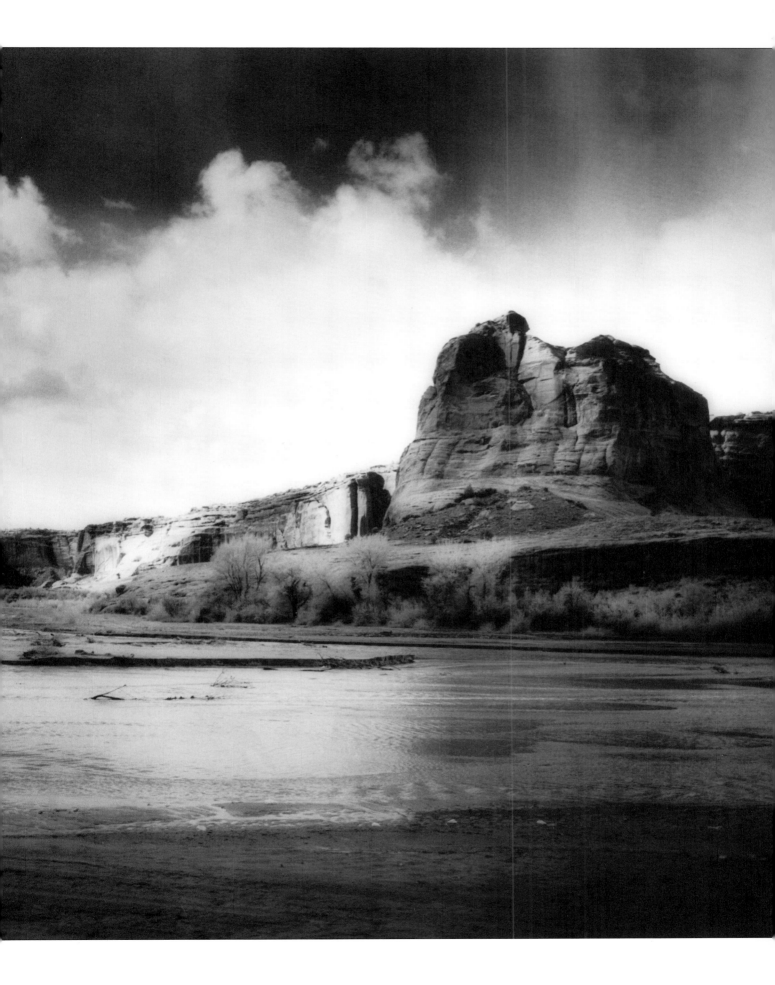

■ Location

What I found so exciting and photographically promising about this location was the vast amount of these eroded adobe walls strewn about the grassy plain. With so many oddly shaped sculptures in a natural setting such as this, how could I not get a good shot? I tried various angles and experimented with the lighting and some backlighting. I wanted to squeeze everything I could out of this great site.

■ Depth

I found that the best shots were those that suggested depth in the final print. After all, the key element that made this place so peculiar was the fact that these walls were everywhere.

■ Tripod

Stopping down to ensure sharpness or increase depth of field may require a tripod. Unless I am stopping down for a shot, I tend not to use a tripod very often simply because I want to maintain the mobility of hand-held shots. If a tripod is to be used, make sure it is one that is first and foremost solid and reliable. Even if it is used only sparingly, it is crucial to have one that is easy to operate, solid in design and provides steady support for whatever size camera is being used.

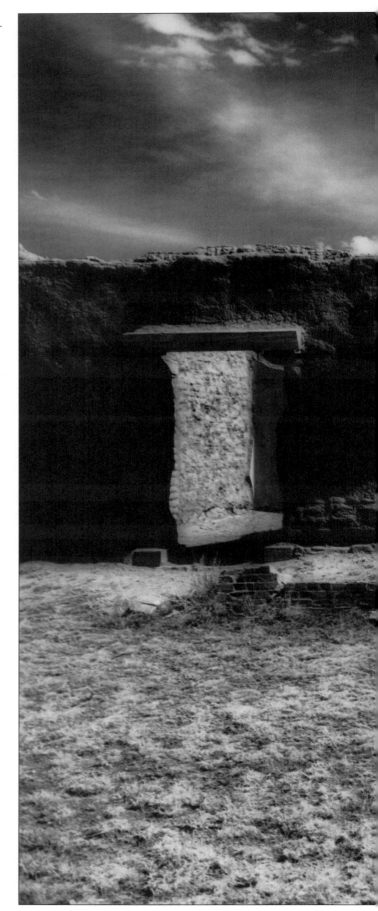

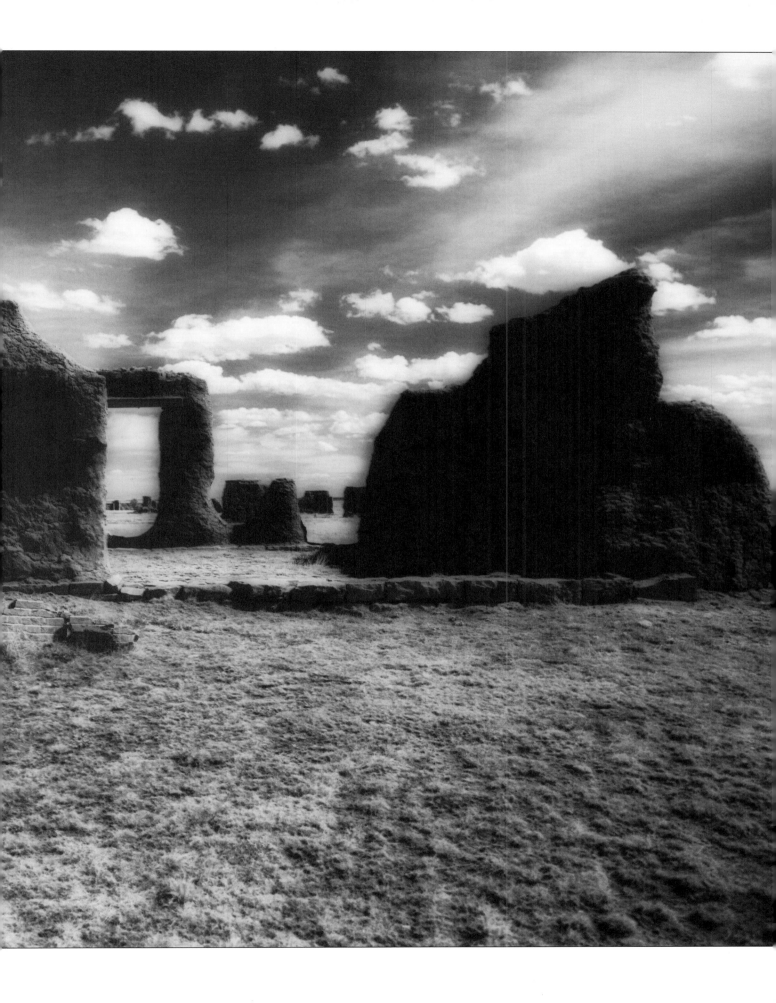

■ Shape and Texture

These were some interesting shapes on the floor of a kiva, a room that was built by the Anasazi for ceremonial purposes. The unusual shapes of the stone structures on the floor were what caught my eye. While composing this shot, I tried to provide an interesting backdrop. The ruin in the distance and some clouds were all I had to work with here.

■ Filters

Infrared film has an extended range of sensitivity that goes beyond standard black and white film and therefore captures what standard black and white captures plus the range of infrared to which it is sensitive. Of all the light that exposes infrared film, the more of it that is infrared, the more the image will have that infrared glow, provided the film is sensitive to those frequencies of infrared waves. If visible light is being used to expose the film, then the images created will have a look similar to standard black and white. The purpose for using a filter with infrared film is to block non-infrared light waves from exposing the film. The darker the filter, the more visible light is withheld. Using a dark red filter, which is the recommended filter and the most commonly used, creates a dramatic effect. However, the subsequent loss of light may require the use of a tripod, depending on both the lighting and the film. The opaque filter, which at first glance may appear to be a lens cap, can create even more spectacular shots. It is a black plastic attachment that is placed at the end of the lens like any other filter. If the camera being used has a through-the-lens viewfinder, then the photographer may need to use a tripod to capture specific shots. It is necessary to experiment to determine the correct exposure using this filter. Ultimately, a good deal of trial and error is required, but the results are spectacular and well worth the effort. Some may disagree that this interferes with composing the shot, but I've always composed through the lens with the filter in place because I've found that it gives me a good sense of how the shadows will translate. Because infrared in general has a slow ASA, substituting an orange filter, which is less dense than red, is one way to increase the speed slightly. This will also reduce the infrared effect slightly but could provide an extra stop when needed. If you use a number of lenses, invest in a filter for the largest lens and purchase adapter rings for the others. This will eliminate the cost of purchasing filters for each of the lenses. Another item to consider is a lens hood. Because I compose through the lens with the filter in place, it can be difficult to see light refracting through the darkened viewer. A hood greatly reduces the chance of light bouncing across the lens.

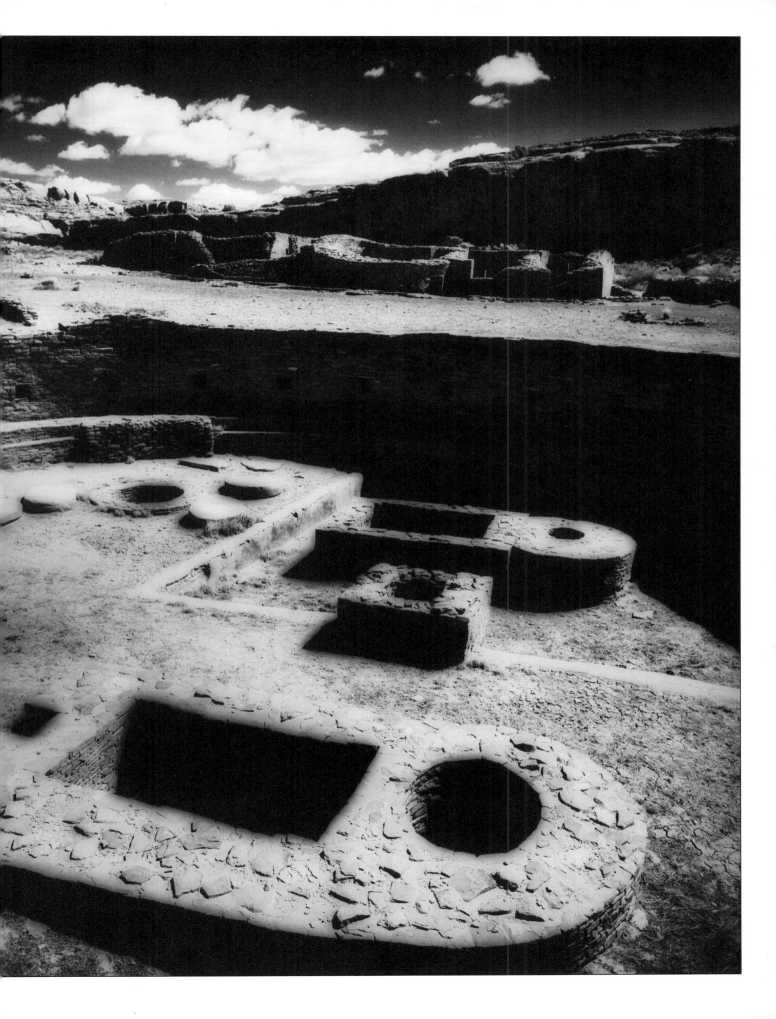

■ Composition

Here I wanted to break up the composition a little more than I usually do. I was trying to capture the large ruin on the left with just a small fragment on the right, to suggest more of the ruin continuing out of the frame. With the opening, I wanted the viewer to get a sense of how open and vast the area surrounding this ruin was.

■ Shadow Detail

It always surprises me when IR picks up detail in the shadows. Don't get me wrong, the detail is minimal in this shot, but since shadows in IR more often go absolutely black, it is considerable. A slightly increased exposure helped capture that detail and also created slightly denser highlights.

■ Darkroom

I was surprised that the distant background didn't require extensive burning in to compensate for the increased exposure. While printing, I try to retain that information as much as possible if it works within the image.

■ Planning a Shoot

The first step in planning a shoot begins with taking not only the right equipment, but being prepared for any surprises. If at all possible, it would be a great advantage to the photographer to bring two camera bodies. Packing the same format and brand makes it possible to interchange the lenses and shoot two different films. If nothing else, it provides peace of mind and ensures your day won't be wasted if one camera isn't working. Also remember batteries for cameras, flashes, and any other electronic gadgets. In a remote location, this simple oversight can be disaster. Making a list several days in advance and making additions as necessary is also a good idea. You may wish to file this list or put it on a computer disk for the next shoot. The bottom line is be prepared for anything, so you will not only return with some shots, but can also enjoy the trip confident that you are prepared. I have found that preparation is absolutely crucial to producing the best work.

■ Traveling

Every three months or so I take a trip to an area that I am interested in seeing. The first step is researching the specific area and its surroundings to get a sense of what is there and what I definitely must see. The option to visit nearby sites must also be kept available. While books and photographs are informative, I've found the best information comes from friends who have visited the area. Once I establish specifically where to go, I then plan an itinerary to manage the time that I have, making a list of where I need to be on each day and sometimes making arrangements for hotels in advance (if the area is a popular place). I try to keep a tight schedule; however, it is extremely important to be open to the unexpected, to recognize and take advantage of what promises to be a good shot, and most important to be patient. Making a routine of the planning process and packing the necessary equipment grants me the freedom to concern myself with the image making process when I'm on location. The fewer distractions the better.

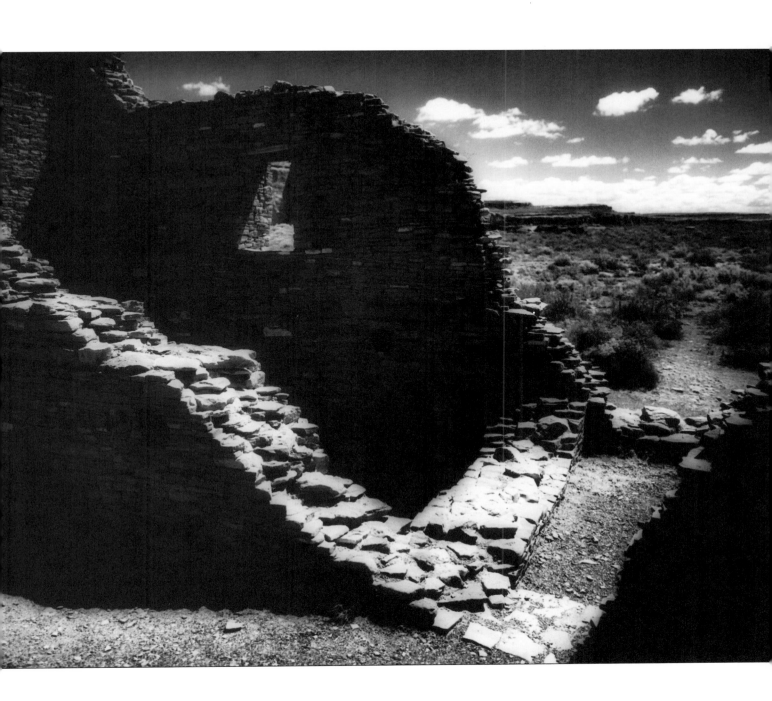

■ Composition

Sometimes the shapes that exist in nature catch the eye of the photographer. I was drawn to the shape of these stones simply because they so closely resembled a grave with a tombstone. Sometimes the elements are laid out in a manner that gives the shot an definite identity.

■ Light

Haze, fog, smoke, overcast and especially cloudy skies all have an effect on the light. To produce a dramatic shot that possesses an eerie infrared glow, it is best to shoot when there is an abundance of infrared waves, which would be found on a clear sunny day. Fog, haze, and clouds all reduce the contrast of the shot, which in turn effects the dramatic element of the film. If the photographer finds him/herself in a situation where the light may or may not be sufficient to capture that infrared glow one method of testing this is observing the shadows. If they appear deep and well defined, the lighting is sufficient. If they appear murky and shapeless, chances are the shot may appear rather flat. The photographer has one of two options: either wait for the weather to clear (even if only for a brief moment) and then make the exposure, or make an exposure using the available light regardless of how unappealing the light may appear. The obvious appeal of infrared is the dramatic look it creates, but that doesn't necessarily mean all good shots are captured in perfect weather. There is no such thing as bad light, only bad use of available light. Be resourceful with what's available, look for those shadows regardless of their depth, and make use of them. It may just so happen that a shot taken in cloudy weather produces something truly unique.

■ Evaluating Your Photography

A photographer needs to be his/her toughest critic and develop the skills to recognize solid work, because it is those skills that will determine the look of their own work. An important factor that the photographer needs to keep in mind when thumbing through the portfolio and making final decisions on what stays and what goes is keeping an objective opinion. It is very helpful to get opinions of others, more qualified or experienced than yourself, for a fresh outside perspective. It can be easy to become attached to an image for sentimental reasons, rather than aesthetics. An outsider won't have that attachment. Familiarize yourself with the industry in terms of who is doing what, and make visits to the local galleries. In other words, see as much work as possible, and become familiar with other photographers and their work, both locally and abroad.

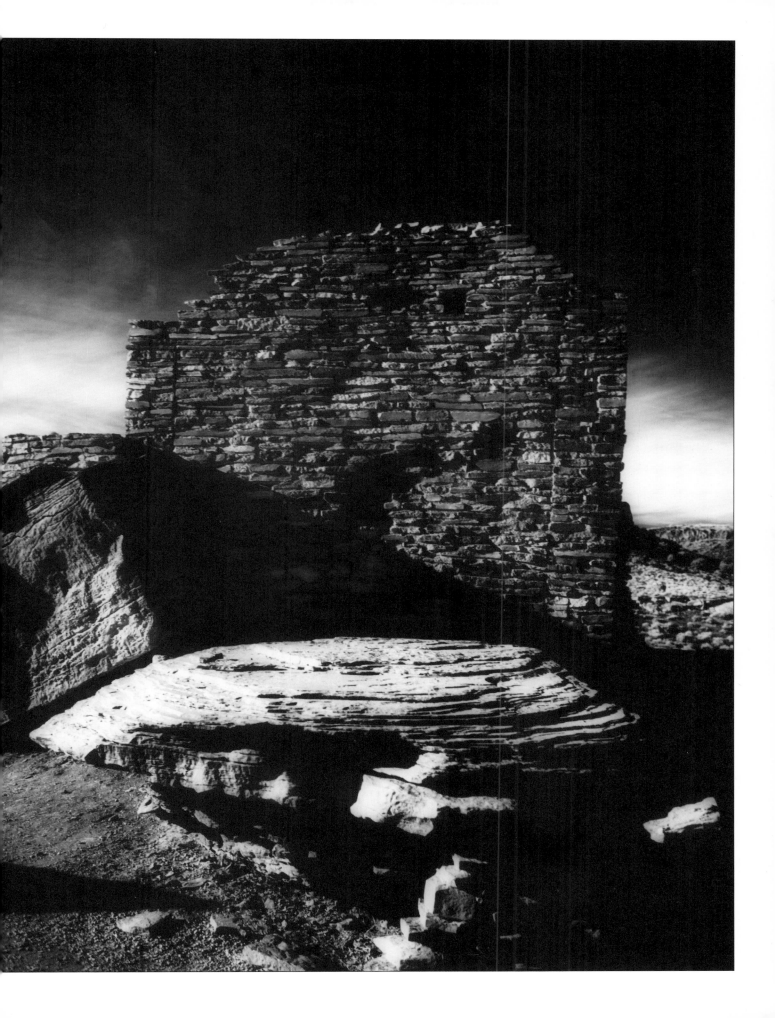

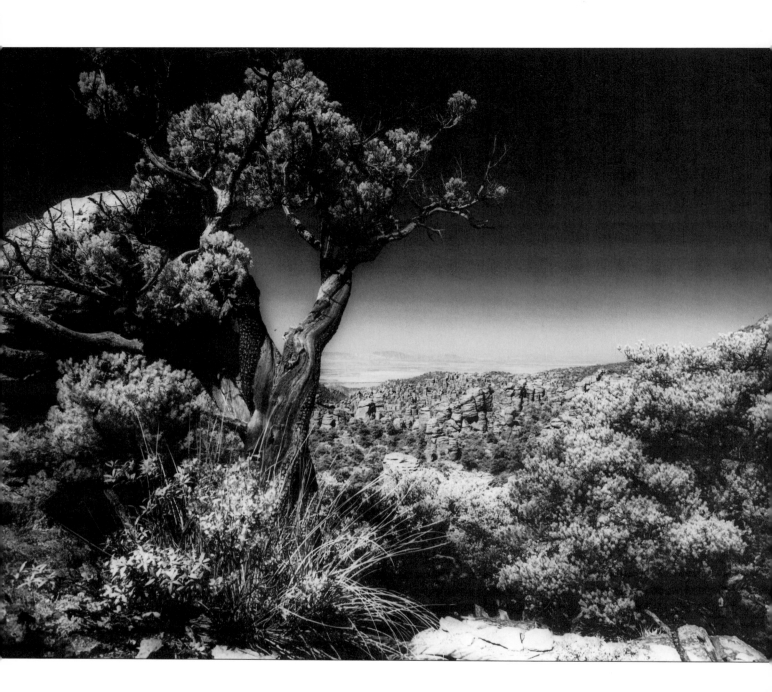

■ Composition

I wanted to capture the rock formations in the distance while providing the image with a foreground. However, I knew the rock formations couldn't hold up at this distance, especially coupled with the fact that the position of the sun wouldn't work to my advantage. Thus, I relied on the foreground to provide the viewer with some interesting shapes. I also composed this with the tree positioned in the foreground so it would break up the uniform, black sky.

■ Shadow Formation

The lack of shadows tend to blend one shape into another because the tones of these rocks are identical. When shooting infrared, look at both the tones of the objects and how their shadows separate them.

■ Horizontal vs. Vertical

It is natural in landscape photography that the majority of the images will have a horizontal orientation simply because the typical landscape, with its endless scenery that lies to the left and right, compose more naturally as horizontal images. This would explain the existence of panoramic cameras. That is also why when vertical shots are viewed, they will often appear to have a more dynamic composition, or present the subject in a manner that is somehow visually more compelling or captivating. Obviously, if one set out to capture only vertical shots, there would be no shortage of such shots; however, the number of them that truly possess an interesting composition might be smaller in number. Vertical shots will often contain diagonal shapes or lines that break up a composition into a series of uniform shapes. Horizontal and vertical elements or shapes may also suggest rhythm or balance in a shot, or a lack thereof, especially if there are a number of these elements within the shot.

■ Bracketing

One more reason for bracketing is the limited latitude of the film. In general, all infrared films produce negatives with more contrast than that of standard black and white films. This is due both to the film's inability to capture sufficient shadow detail (which creates deep shadows) and its sensitivity to the infrared waves (which creates brilliant highlights). The unforgiving nature of infrared film demands of the photographer a properly exposed negative. This limited latitude also means that the film is virtually unaffected by pushing, or increased processing to compensate for underexposure. Again, it is important for the photographer to make accurate exposures with infrared film because of the limited options to correct any miscalculations made during the exposure. The easiest way to ensure a printable negative is bracketing. Don't be discouraged by the seemingly lengthy list of quirky aspects of using infrared film. As the photographer gains experience with these films, it becomes easier to identify scenes that might present exposure problems.

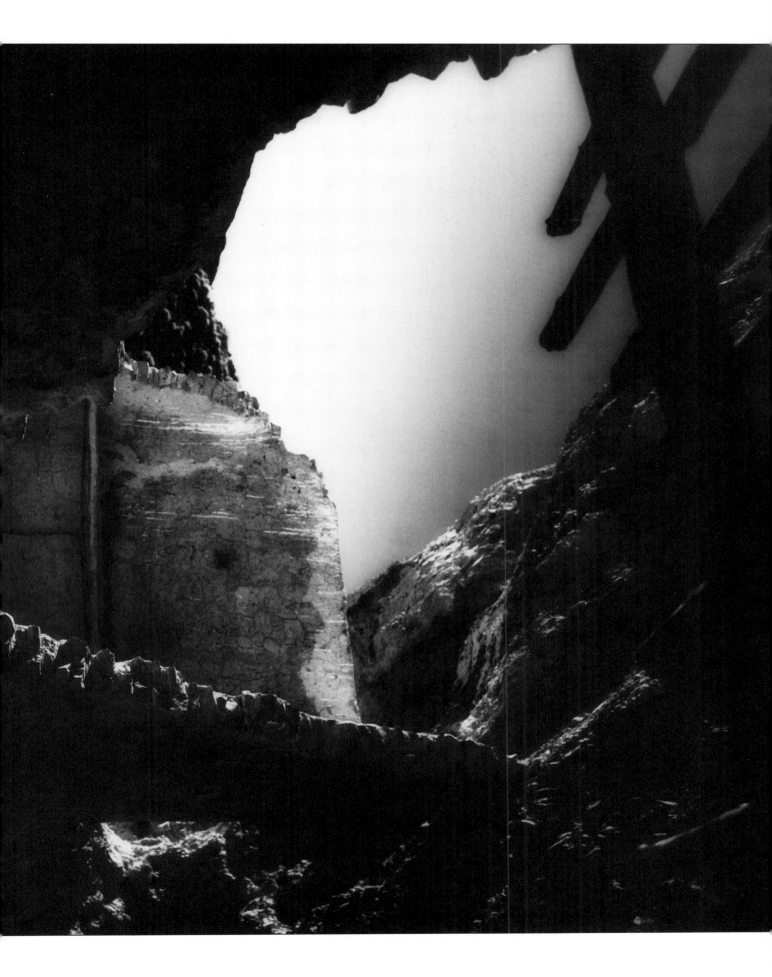

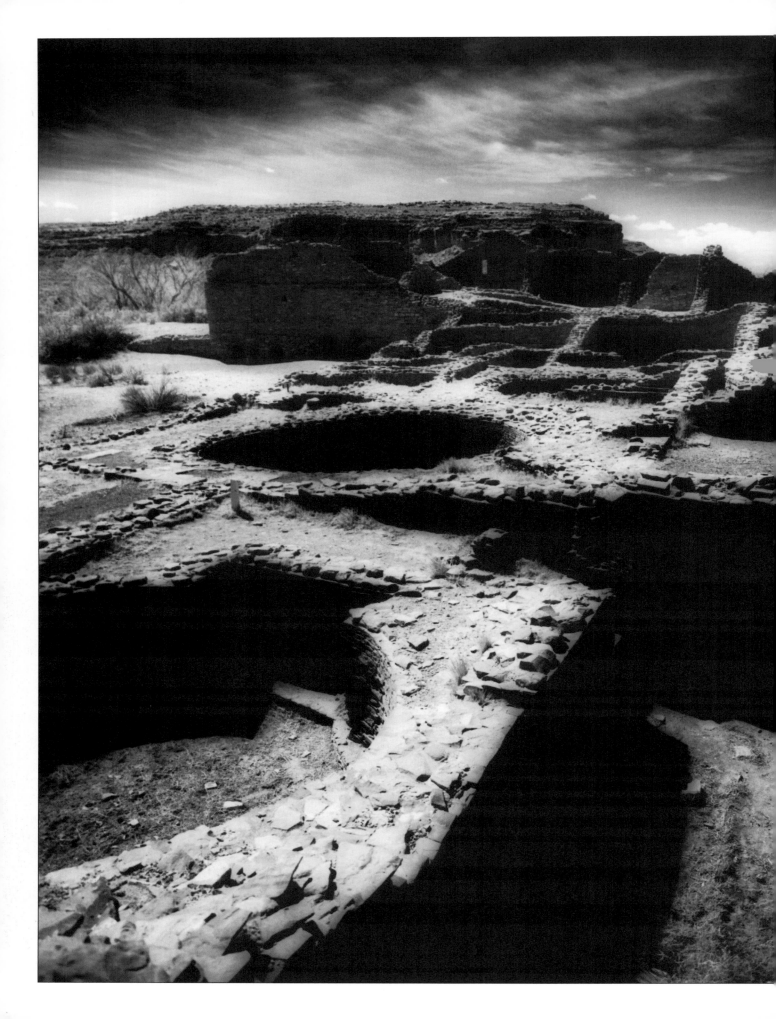

■ Shadow Detail

I wanted to capture the busy, unusual shapes of this ruin. I shot with the camera positioned a short distance from the ground because I wanted a main feature in the foreground to anchor the image. Lowering the view helped to create some larger shapes in the foreground and yielded a stronger composition.

■ Darkroom Technique

The task of making prints is very much like taking photographs in that it requires patience and time. First, always maintain a clean environment. A clean, organized space with good ventilation will make it more comfortable for the printer to spend time producing good work. Organize the darkroom so materials are accessible but not in the way when they are unneeded. Also, small details can make a difference. Items such as a clean supply of hand towels, paper safes, and clear counter space can make time spent in the darkroom less labor intensive. Once the darkroom is clean and comfortable, the printer can then focus on the work at hand. I've found that the very best prints, those with an interesting composition of shapes complemented by unusual lighting, are made from negatives that were properly exposed in the camera. Of my best prints, not one is the result of countless efforts in the darkroom trying to correct improperly exposed film. Sure, some need more work than others, but there's a line that exists between getting the best print possible and struggling to make the best of a bad negative. This underscores the need to get the shot right, rather than spending countless hours in the darkroom trying to salvage bad negatives. In other words, when the photographer finds a great shot, this is not the time to be miserly with film; take the time to properly compose, focus and bracket the entire roll if necessary.

■ Surprises

As I mentioned earlier, infrared film has an element of surprise regardless of how experienced the photographer is. The sky tends to provide most of the surprise, as with this image. As I set this shot up, I wanted to take advantage of a pattern in the clouds, and composed with that pattern in mind. The cloud patterns stand out dramatically from the dark sky and form the basis of the photograph's composition.

■ Diffusion Printing

A diffused print is one that has a softened look. This softened appearance is created by placing a translucent material in the enlarger between the paper and the light source. Frosted glass works well, as does cardboard with a hole cut in it and covered with a silk or nylon material. During the diffusion small details are eliminated, creating larger areas of less detailed information. Shadows will bleed around the edges, and highlights become less defined. Most diffused prints are diffused for only a fraction of the total exposure. The printer decides the length or percentage of the diffusion strictly on the basis of aesthetics. When diffusing a print, it's best to break up the main exposure of the print into smaller increments on the timer and simply hit the expose button the correct number of times. For example, if the main exposure of the print is twenty seconds, set the timer at five seconds and hit it four times. The reason for this is that during a number of those shorter exposures, the printer can diffuse the image and only have to remember how many hits on the timer the print was diffused to recreate that print. If the printer has decided that two hits of diffusion aren't enough and three are too many, he may then break up the exposure into smaller increments and diffuse the print for a larger percentage of the exposure. To create prints with a soft look, the main exposure will probably require diffusion somewhere between twenty and sixty percent of the exposure. This range depends on both the desired look of the final print and the balance of shadows to highlights present in the negative. If a larger percentage of the negative is shadows, then lower the amount of diffusion to prevent a soft murky print (unless this is the desired effect). Additional burning in areas that require it should not be done through the diffusion tool. This will cause shadows to bleed excessively and highlights to grow murky, giving the print an extremely muddy and undesirable appearance. There are countless materials for diffusion. Anti-newton glass, plastic sandwich wrap, or any other translucent material will suffice, but keep it simple. The process needs to be practical if the printer is to be productive.

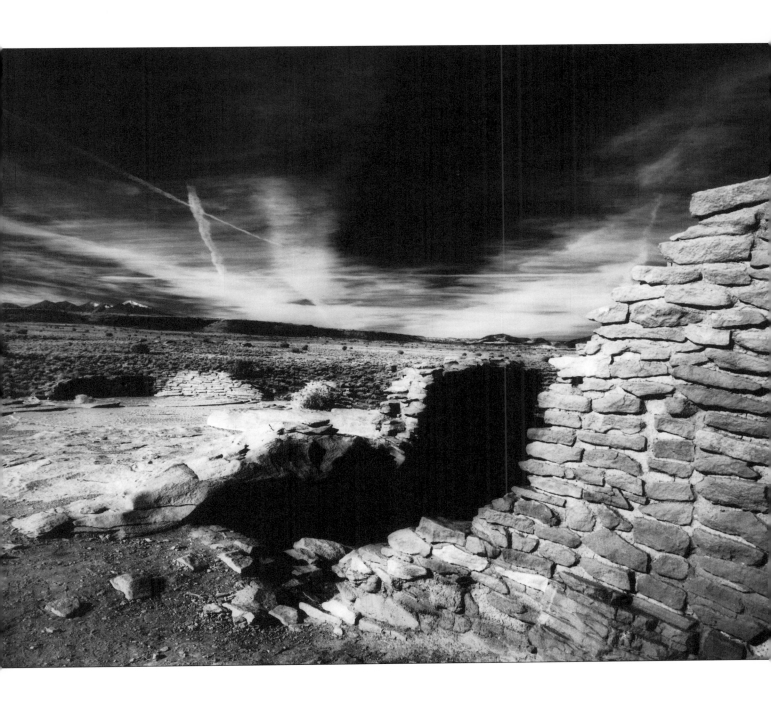

■ Prefogging

Occasionally, the printer/photographer will find that the highlights of a print are overexposed to the point that burning them in is beyond the capacity of the enlarger. Prefogging the paper might help this situation. Prefogging is the act of exposing the paper for a very brief moment prior to exposing the paper for the final print. It makes the paper more receptive to burning, just enough to create tone in those overexposed highlights. Obviously, this situation should be avoided at all costs, but nevertheless, it happens – especially when first learning how to use infrared film. This technique also requires an additional enlarger of some sort (although not necessarily state of the art because it will be used in a very basic way), so it is not for everyone. To prefog, simply place the photographic paper in the easel below the enlarger being used to prefog and set the timer for only a few tenths of a second. Next, make sure the aperture is stopped down to around f-22, lower the contrast, and expose the paper. Then take that paper, place it in the easel to be exposed for the print and go through the normal steps of exposing the paper with your chosen negative. The prefog settings will need to be adjusted just enough to give the print some tones in the highlights. This certainly is not the cure-all for overexposed negatives, but it may rescue one now and then.

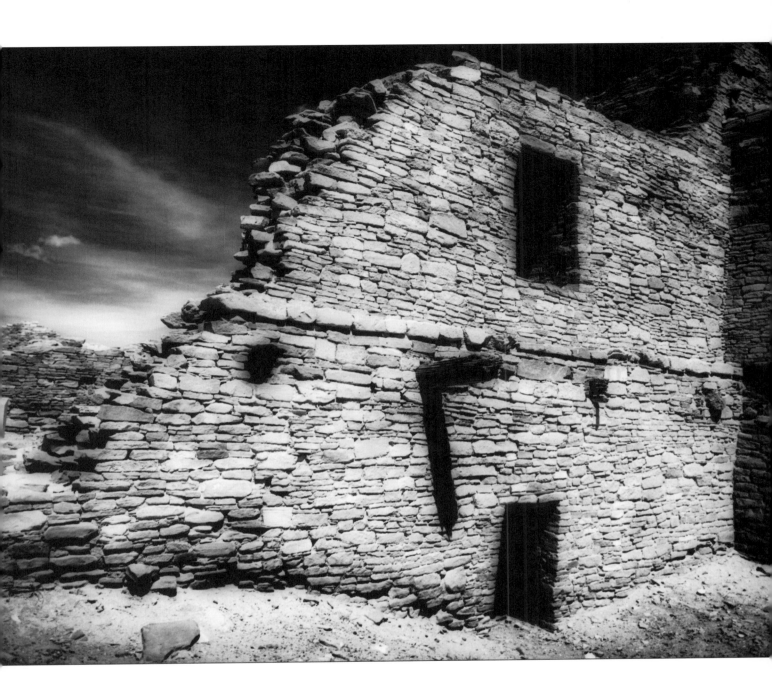

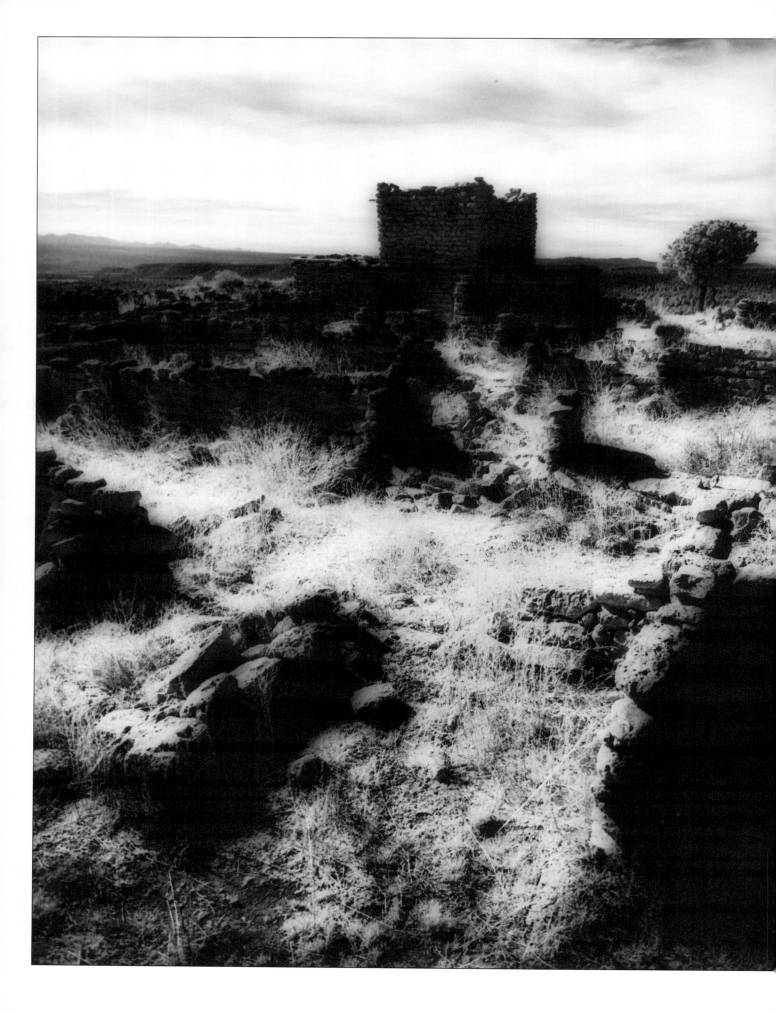

■ Shadow

The lighting in this shot clearly suggests it was taken late in the day. Notice how there is almost no detail on the sides of the square building in the distance. The shot has some interesting shapes, but different lighting could have improved the scene.

■ Toning

Toning is a process that adds color to black and white prints. Colors range from the simple earth tones (blues, browns, and greens) to somewhat unusual colors such as gold and copper. There are two types of toners: simple one-bath toners, or two-bath toners that require bleaching the print first, then transferring the print to another tray that introduces the color. Selenium toner is an example of the first type. Prints are soaked in a dilution of it for a period of time to gain a reddish color. Sepia toner is an example of the other; it first bleaches the print before adding a reddish brown tone. The final results of selenium toning can be altered by stopping the toning process early or reducing the dilution of the selenium. With a sepia style toner, it becomes a little more involved. It is very important to begin with a clean environment, including trays, tongs, gloves and whatever else is being used to handle the prints during the process. Staining, which may be due to contamination at some point during the process or may just be inherent in either the paper or the toner itself, is very common and almost always renders the print useless. Some papers used with some toners are simply a bad combination, and, with so many colors of toners and papers available, testing is the only way to be certain of the results. It is wise to tone several prints

of the same image in the event some are lost because of stains. With the two-bath style of toning, the amount of bleaching effects the final look of the toned print. The more a print is bleached, the more the colored tone will appear. When the toning is complete, the prints will require a final wash for archival purposes. Don't feel limited to using only one color. A toned print can be toned again in another color if the printer wishes to do so, and it may produce some wonderful results. To those that have never toned before, because the entire print is being treated it will leave the usually white borders of the paper toned as well. Sometimes this is a surprise. Selenium and sepia toning are actual chemical processes that affect the silver in the paper, and are therefore permanent. Colored toners are dyes and therefore less permanent. This doesn't mean a toned print can be un-toned, however. Soaking a toned print in a gallon of water with a tablespoon of salt will remove some of the color of the toned print, as will soaking the print in a tray of permawash. The downside to this is that it effects the print as well, reducing the contrast of the image. Use this trick in small doses. Edwal and Berg are the two major brands of toners available on the market. Each offer various colors and different results depending on a number of factors. Some papers tone better than others, but this may also depend on the type of developer used to make the print. With all of these variables, it should be clear that duplicating the final results is downright impossible. When toning for the first time, start with only one or two prints at a time. Once you are familiar with the process, the number can be increased a little.

Lighting and Textures

What appealed to me in this scene was the stratification of the different textures. The swirling grass, the layered rocks, the ruins, trees and cotton ball clouds to top it off. This is a good example of how composing with infrared is very much like composing with standard black and white. In this shot, one gets a clear impression of how well textures can separate themselves with lighting that enhances those textures. But again, the key is the lighting, and it can make or break a shot that deals almost entirely with textures.

Portfolios

This section concerns printing and matting and how best to coordinate one's portfolio to maximize the work and minimize expenses. Any photographer with a desire to pursue an interest in photography for any length of time needs to begin as early as possible to produce work designed to be viewed. What starts out as a hobby or mild interest, if given the time, can easily become a long-term commitment. This section is for those interested in how best to go about printing, matting and framing work that is intended for display in a professional environment. First off, I found that printing on 11x14 size paper was large enough to see the detail of the images, but still convenient to handle. Because I always print full frame, it also worked well because it required minimal cropping from my 6x7 negatives. You need to find a size that presents your images well, and print all of your work the same size. This might sound limiting, but remember, this is only for the portfolio and presentation. If prints of other sizes are needed, they can be printed to other sizes. Now that all the work is the same size, mats can be cut using the same window dimensions, making the mats and prints interchangeable. As time passes and the portfolio evolves, new mats won't be needed as fresh work is added and older material is removed. Use photo corners when mounting the prints so that they are removable. The result of all this is a body of prints presented in mats of identical size, which not only makes them easy to handle and present but also very attractive. If frames are needed for display, they will also be interchangeable. In the end, you'll save a lot of time and money by working with a consistent size print.

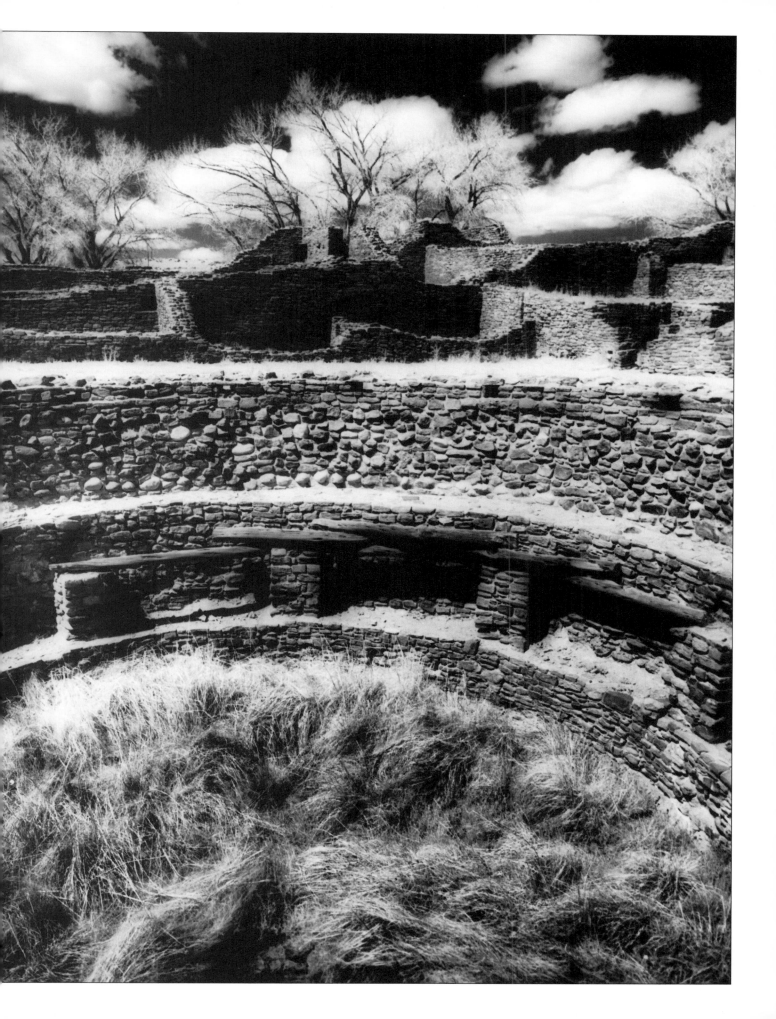

■ Overcast Days

The day I shot this image was quite overcast. This resulted in rather thin negatives. Consequently, I ended up printing this image at a higher contrast than normal. Opening up a stop could also have helped to produce a richer negative.

■ Keep Records

Keeping good records of your work will make your landscape photography all the more enjoyable. First, it is a good idea for anyone unfamiliar with infrared to record exposure information for each shot and review that information after the film has been processed. This record can then provide a reference from which the photographer can gauge future endeavors. It is also very useful to label the film by location – especially if you may have on hand a number of unprocessed rolls from various locations.

■ Processing

There is one quick point to make about exposing and processing that even some professionals overlook. While on location and shooting various scenes, expose each roll consistently. Often photographers take one of three different approaches when shooting on location in an uncontrolled lighting situation that can't be reshot. The photographer who knows the equipment and the film draws on past experience and makes accurate exposures based on the information his equipment provides. The second takes readings often and makes slight adjustments when needed, but not to the extent that exposures vary widely. The third approach is shooting film in using exposures that cover every conceivable lighting situation and using vast amounts of film, leaving to chance whether any usable negatives will be produced. Obviously, the first group is where all camera owners would like to find themselves, but that isn't the case. First timers, novices, and (believe it or not) a small pocket of professionals would make up the third group. If you find yourself in the second group, you are to be congratulated. One of the many advantages to being at this level is the volume of quality work that is possible. When in the field, shoot the film consistently and label it according to location. When the time comes to process all the film, take one roll, process it normally and evaluate the results. Is it too thin? Too dense? Then adjust the processing time and continue with the rest. Too often, photographers shoot a number of rolls from various locations and return with them unlabeled. If one roll comes out thin, there are no options available at that point. With more printable frames to work with, the production of high quality work is sure to follow.

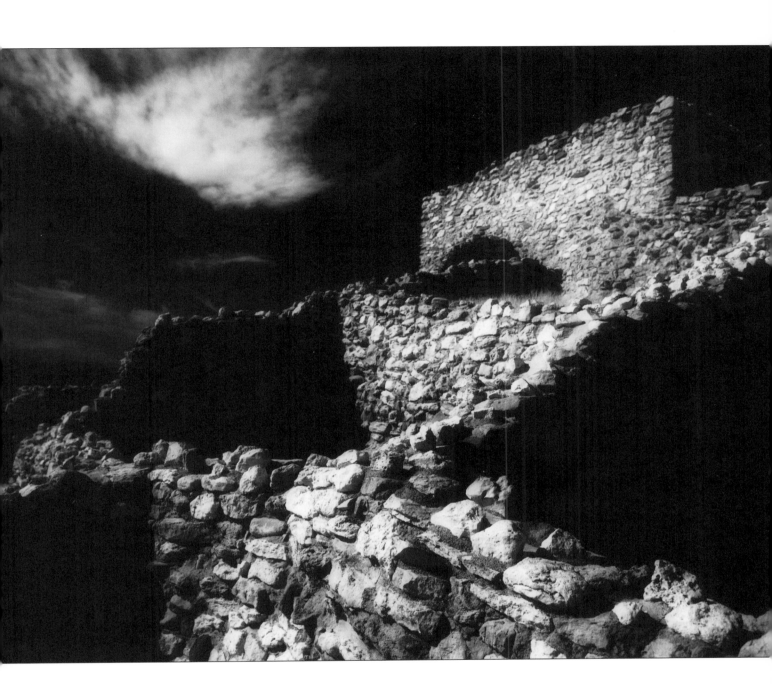

■ Contrast

This stark shot has an awful lot of contrast, due primarily to the subject and location. The white sand of the beach coupled with the dark water and sky made for a dramatic shot with an abundance of strong white and deep blacks.

■ Darkroom

In the darkroom, printing required a low contrast filter to even out the wide range of tones.

■ Camera Format

With each camera size or format, there are a list of advantages and disadvantages. Obviously, 35mm is convenient not only in terms of size but also in cost. A person can spend as much as he/she desires on a camera, but in general 35mm is the least expensive of the formats. With its easy use and convenient size, it is no wonder it has become so popular. The drawback to 35mm is the same feature that makes it so convenient: the size of the negative. Because it is so small, there are limitations on how large an image can be printed. Medium format offers a larger negative, which in turn allows larger prints to be made with a higher degree of sharpness. Printing from a larger negative is an enormous benefit both in terms of print sharpness and the amount of work that goes into producing that print. The drawback to a medium format is a slight increase in cost, depending on the equipment. Medium format cameras range from a thousand to several thousand dollars. The other drawbacks to medium format are a loss of speed and a physically larger piece of equipment. This is also true, in general, of large format cameras. The benefit with this format is not only incredibly sharp images, but the capacity to correct converging lines that appear most often in architectural subjects. The drawback to the format is that, aside from being a large piece of equipment, large format cameras also require loading and downloading sheets of film into individual holders. Ultimately, the choice comes down to convenience versus image quality. Certainly there are other smaller factors, but that is essentially what lies at the heart of deciding which format is best for you. Personally, I shoot medium format to take advantage of the larger negative without the burden of lugging around a large format camera with film holders.

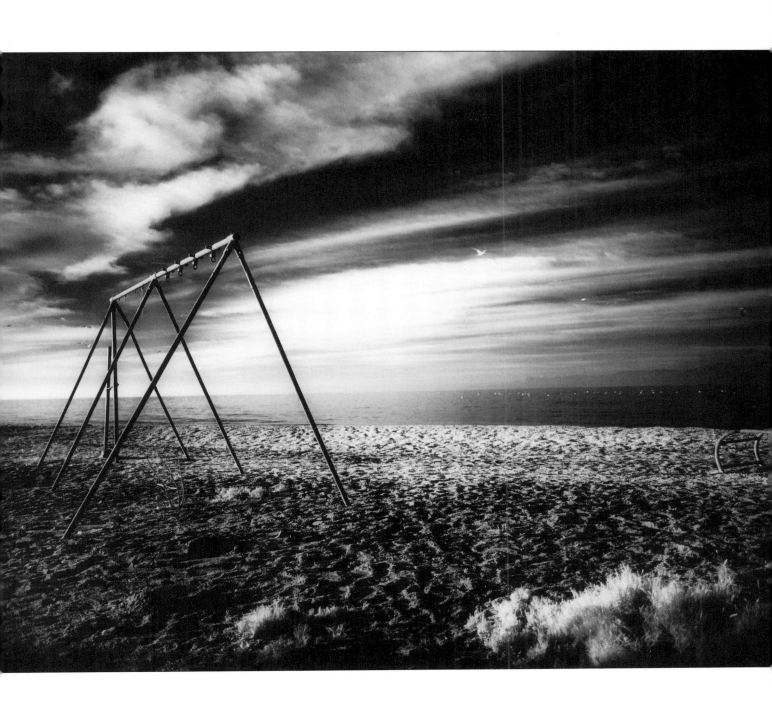

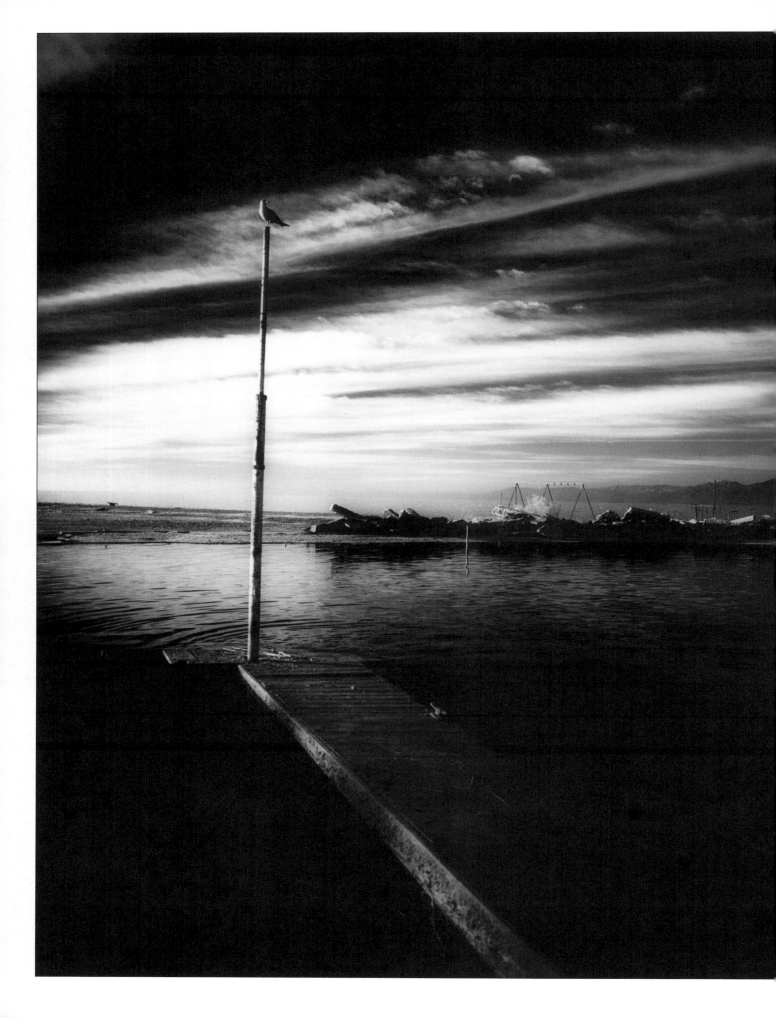

■ Vignetting

Here is a another good example of how the infrared creates a vignetted appearance, although the subject matter increases the effect. To reduce this effect, the photographer can open a stop or possibly two, but that may risk overexposing any highlights and may affect the depth of field. Increasing the exposure will give the shot more of the typical infrared glow, and lighten the image in general. However, just keep the related factors of focus and overexposure in mind when doing this. There is also no drawback at all to bracketing the shot.

■ Predicting Results

Over the past seven or eight years I've shot thousands of rolls of infrared. Despite this, I still don't always know exactly how what I see will translate in infrared. This is due to the simple fact that infrared light waves are invisible. While shooting, I know what to expect in terms of lighting and composition. Looking at a landscape, one can easily evaluate the light and shadow formations of the subject, as well as the direction and quality of the light. It is the extent of the infrared effect that can be a surprise. The good news is that the majority of the surprises work out to the photographer's benefit, resulting in dramatic effects.

It might seem like infrared is a little chancy, but that gamble is part of the appeal. With standard black and white film, I know exactly how the tones will translate and how the objects in my frame will appear in relation to each other. Because of this, I find it far less exciting and challenging to take standard black and white film back to the darkroom – precisely because of the predictable results.

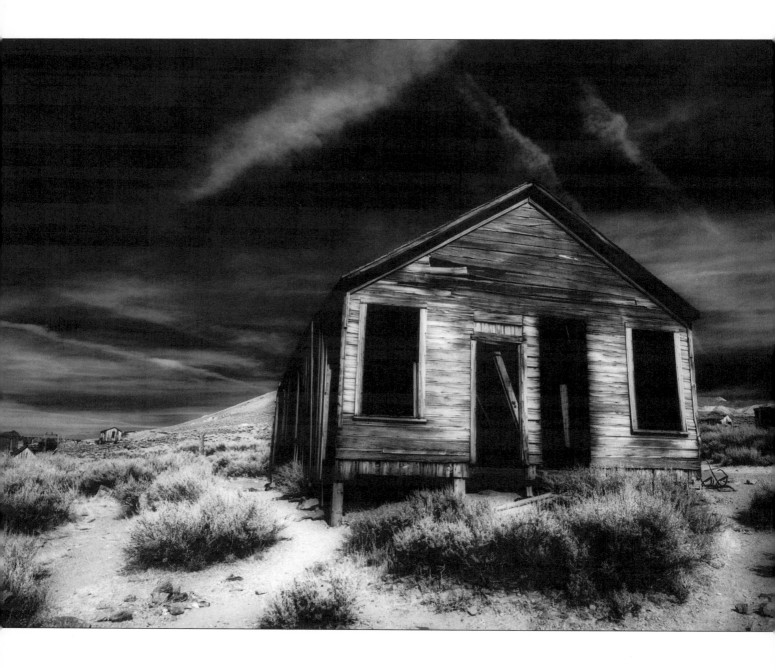

■ Composition

Composing is much like assembling a puzzle. You find pieces that fit together and, once assembled, they create an image that is visually rewarding in some way. Composing a landscape shot begins with locating an interesting element, be it a stone, a tree or even something more complete – such as an entire background like a mountain or forest. Once one piece of the puzzle is found, you may begin the search for another that will complement it. Alternately, you may prefer to simplify the subject and feature a single element on its own. That is a choice the photographer must be aware of, as those decisions are ones that will determine the manner in which the work is presented. Typically, the first thing I find is a background, simply because it is more visible (a range of hills or a sunrise is quite hard to miss). Once the elements have been found, it is simply a matter of arranging or composing them within the viewfinder. This is often determined by the lighting, its intensity, and working out which angle presents the subject best. After I've arranged the shot, I fine tune the composition while looking through the viewfinder. I pay close attention to the corners of the viewfinder. That is where seemingly unseen objects make their way into the image. Once those details have been finalized, I take a reading with the light meter, double check the settings on the camera, then make an exposure or two. If the lighting is unusual, or I feel this shot has great potential, I take another(maybe two, simply for insurance) with a bracket of one stop.

■ The Potential of IR

In general, infrared is a film that captures images in a dramatic manner. An infrared image that doesn't have a dramatic feeling to it isn't necessarily a bad shot, it just doesn't take advantage of what the film offers. There are plenty of shots that can be taken using infrared and which won't have a terribly dramatic feeling to them, but there are countless more that will. It is simply a matter of how the photographer chooses to present the subject.

■ Exposure

When faced with a lighting situation that is either unusual or insufficient, a simple bracket of one or two stops should solve the problem. An increase of the exposure will also increase the infrared glow within the image. There is a fine line between a correctly exposed negative with printable highlights and maybe a trace of shadow detail, and a negative with substantial shadow detail and excessively dense highlights. Take the time to check the aperture and shutter speed settings before each shot to ensure a properly exposed negative.

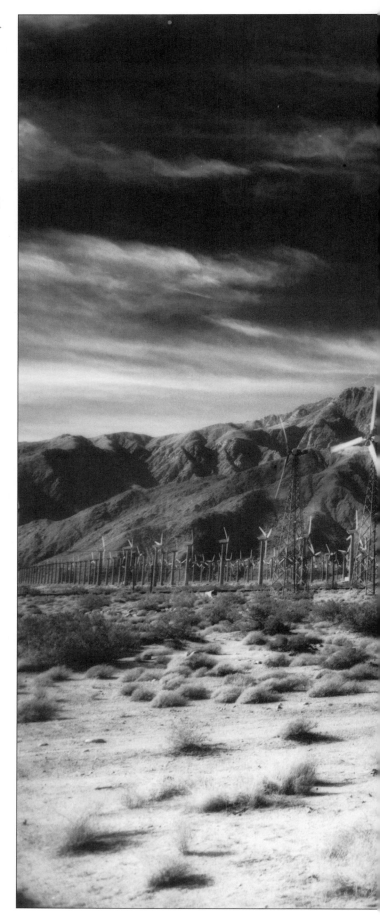

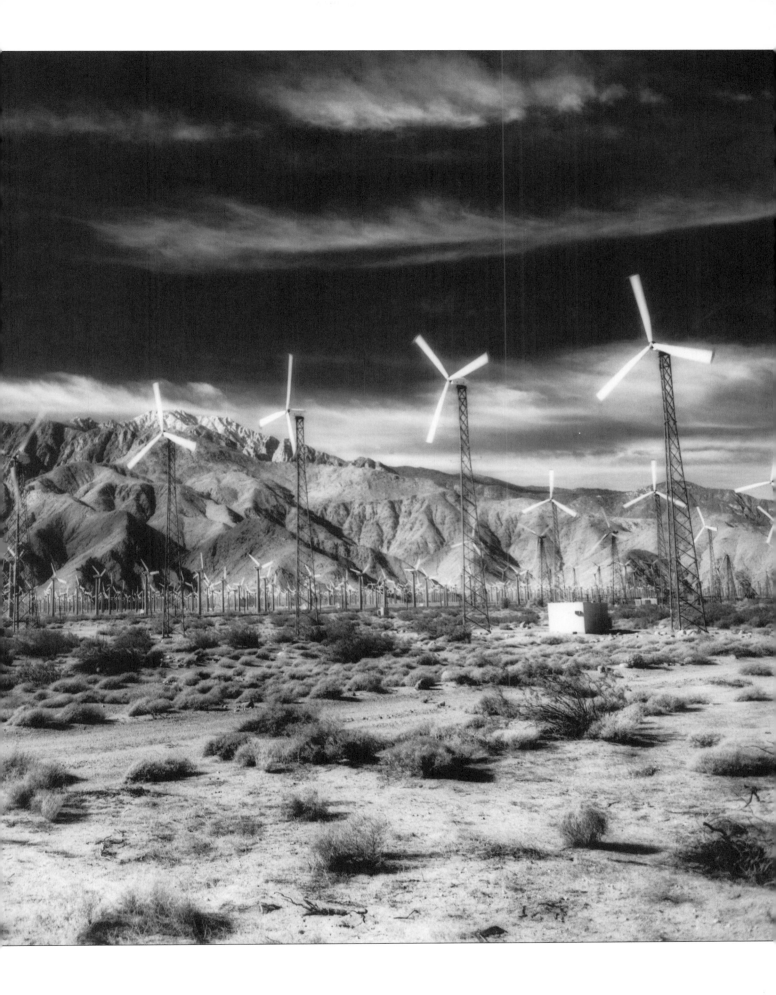

■ Vertical Composition

There are several elements in this image which I wanted to put to use. First, this porch structure made the shot an ideal vertical composition. When shooting with a camera that generates a rectangular shaped negative (as opposed to a square), the majority of landscape shots probably will have a horizontal orientation. Images with vertical orientations tend to have a more dynamic composition. In this shot, the strong vertical lines and repeated rectangular shapes within the image, along with the dark shadow at the bottom, serve as a foundation for a solid composition.

■ Reflections

A unique element that sets this shot apart is the reflection in the window on the left. When composing, I made certain that the reflection was a highlight. Had it been dark, it would certainly have reduced the strength of the image.

■ Exposure

Because of the wide range of tones, I had to open up to capture detail of the stones in the shadowy foreground. In the negative, this resulted in rather dense areas, specifically the clouds and landscape on the right. The extra effort required in the darkroom to compensate for this was minimal and certainly worth the time.

■ Diffusion

Also, a closer look at the poles will reveal how the diffusion process causes the dark shadows to bleed into surrounding highlights. There are times when a shot such as this presents the photographer with a very wide range of tones that may be difficult for a high contrast film like infrared to capture. The best solution is to bracket consistently.

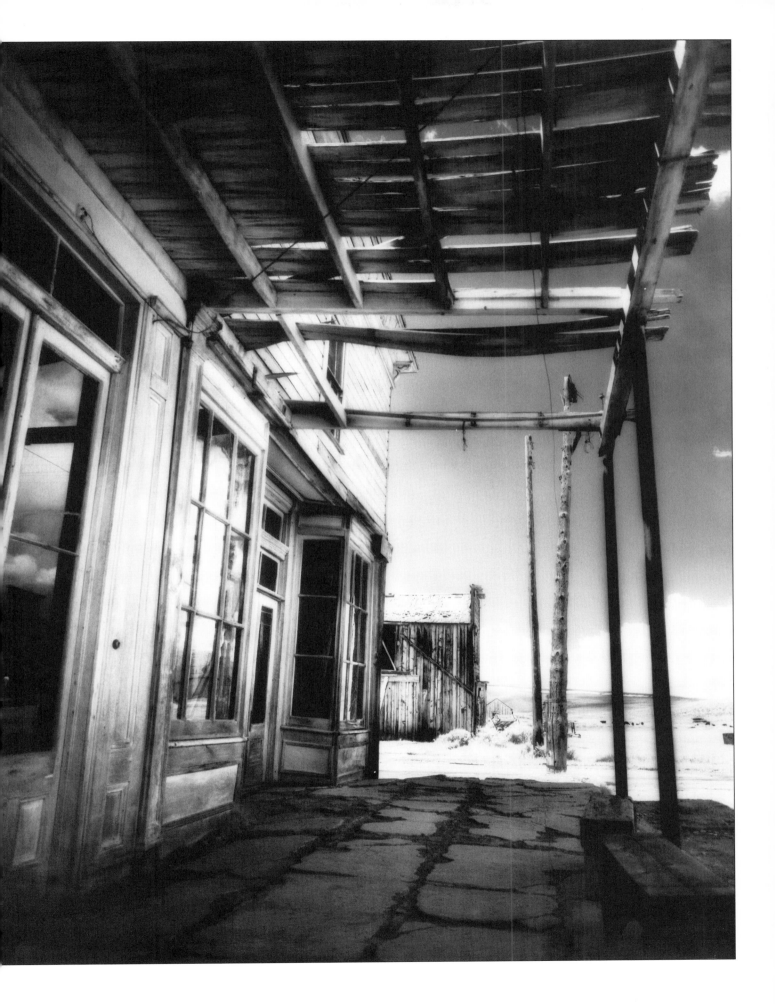

■ Composition

What makes this shot interesting is the three-dimensional look of the building with the shadows of the clouds in the background. I make a conscious effort to compose a shot with the subject slightly offset to one side. This creates some interesting tension or imbalance in the shot. Centering the image would not have created the same feeling.

■ Printing

The windows on the old shack are covered with wire, but the absence of this wire in the print demonstrates just how contrasty this film can be. When confronted with burning in any large area of brilliant white highlights, as with this shot, be careful not to burn them in excessively. Too much burn will give the image a muddy or murky appearance because many of the highlights within the shot will be reduced to less than white. I print all of my own work slightly diffused, which gives it a softened appearance. Using a small piece of anti-newton glass under the lens of the enlarger for a fraction of the exposure produces a softer look to the print. Sometimes black shadows will bleed a little into surrounding highlights, adding to the already eerie look of infrared. It is important not to burn in highlights or white areas of a print while diffusing. This will give the print a very murky appearance. If burning is required, do it without a diffusion tool.

■ Light

The frontal perspective, directly head on with the sun almost behind me, is something I rarely do simply because it greatly reduces the shadows in the shot. Here, I was counting on the shadows in the distance to provide the depth I wanted in the image.

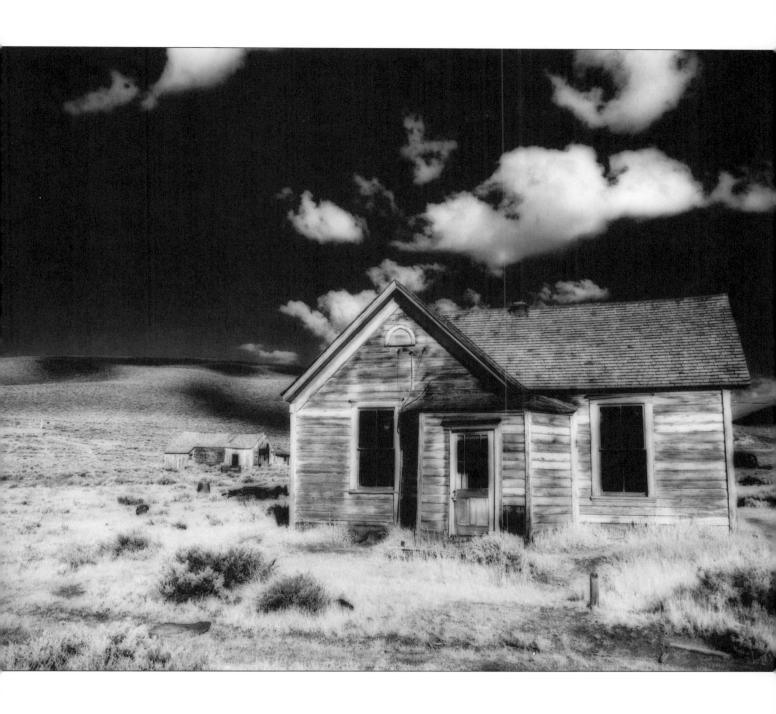

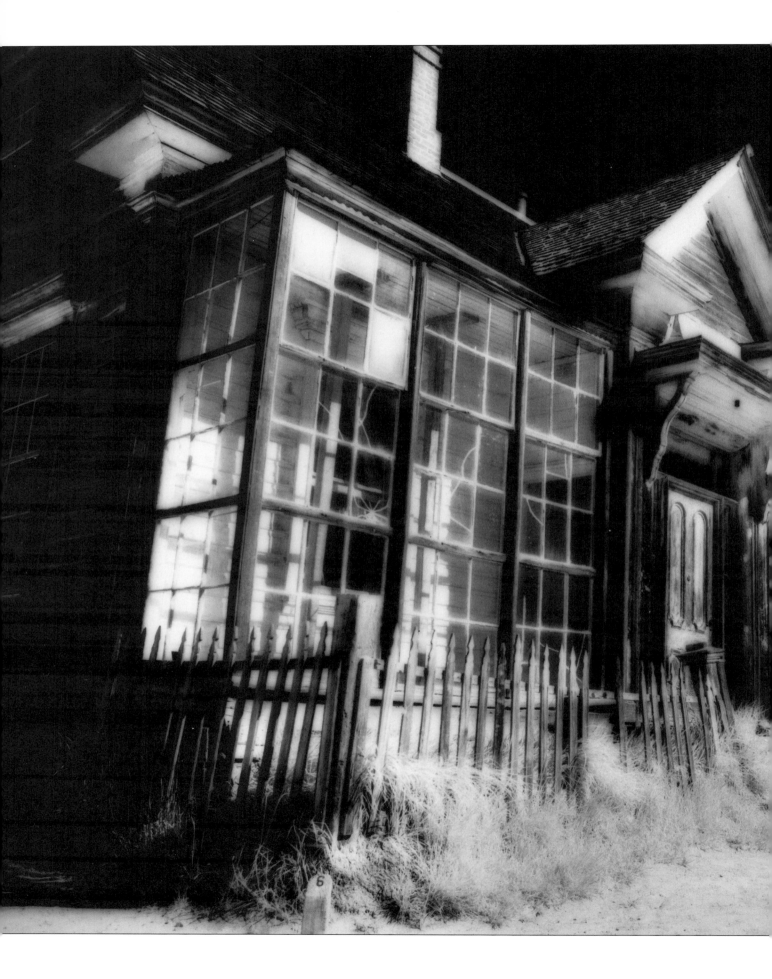

■ Setting

This stark structure with the picket fence and enclosed sun room immediately caught my eye. It has a very unique look about it. A small bonus to shooting infrared with a cloudless sky is the fact that it hides telephone wires nicely. There were several attached to this building above the entrance. This may not come in handy every day, but it is something to keep in mind when trying to reduce or eliminate certain objects from a shot.

■ Composition

When I compose a shot, I will often use a large element, such as this old shack, on one side of the shot as a focal point and include some smaller shapes in the background to give the viewer something to see beyond this main element. Something the photographer should always keep in mind are the sizes and shapes of the objects being included in the shot. Be aware of how they affect the composition, how they compliment each other, and also how they are arranged spatially. If the shapes overlap, it is important to consider whether the tones will blend into one another. Small details like this can make or break even a very interesting shot.

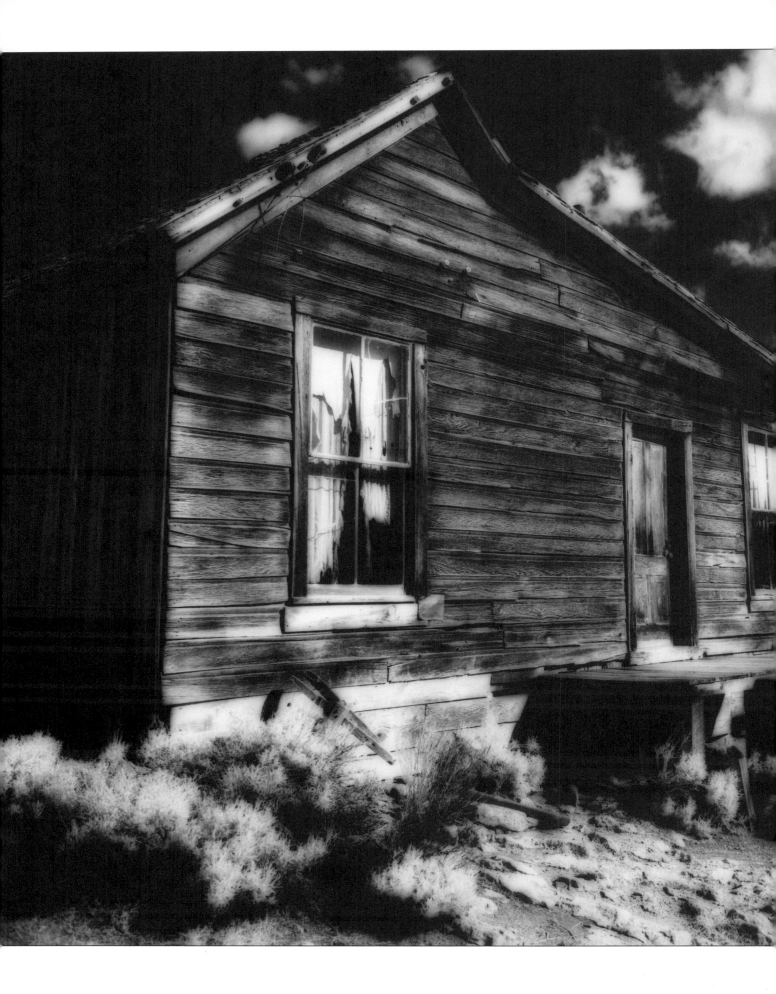

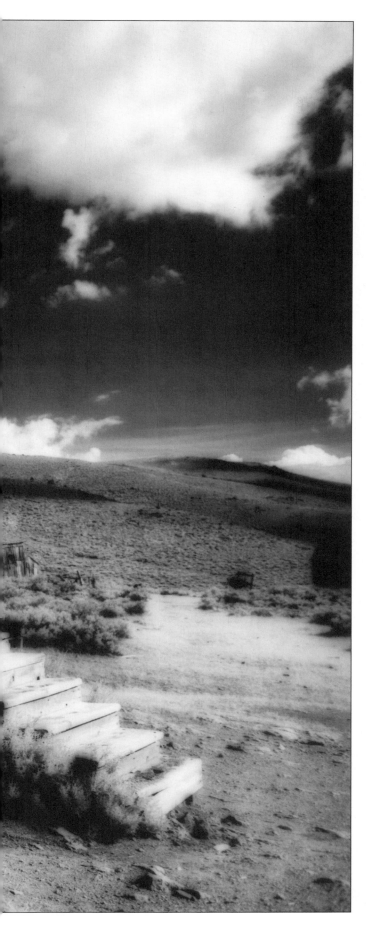

■ Composition

This was a second effort shot. I had photographed this building a few years earlier and wasn't happy with the results. I knew I could do better. The next time I visited the park, I made sure to improve upon my previous efforts. The first shot was taken at an angle that almost completely filled the frame with the building. On this attempt, I wanted to leave some room in the frame to capture some of the surrounding area. The beautiful clouds certainly didn't hurt the shot either

■ Evaluating Light

When faced with cloudy weather, I've found that observing the presence of shadows serves as a reliable indication whether enough sunlight is present. If good, strong shadows exist, then it's usually possible to get a decent shot – and the darker the shadow the better.

■ Traveling

When I travel, the weather is the only factor that keeps me on edge. It is crucial to good infrared landscapes, and there's no controlling it. It's important to have an alternate travel plan to fall back on if the weather doesn't cooperate.

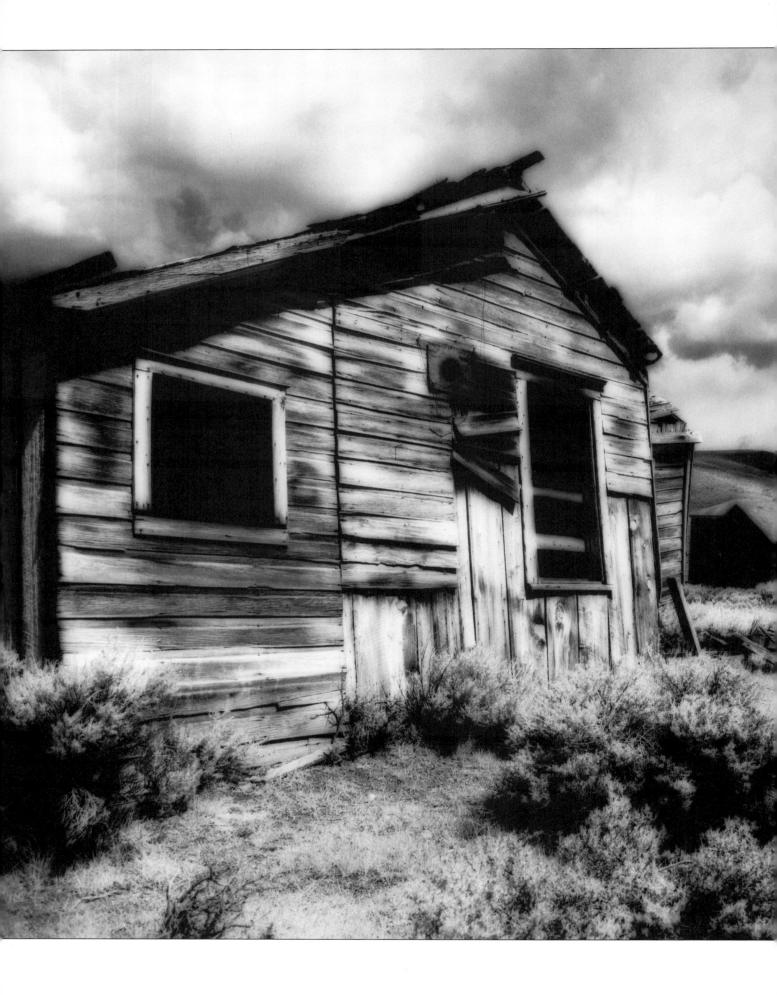

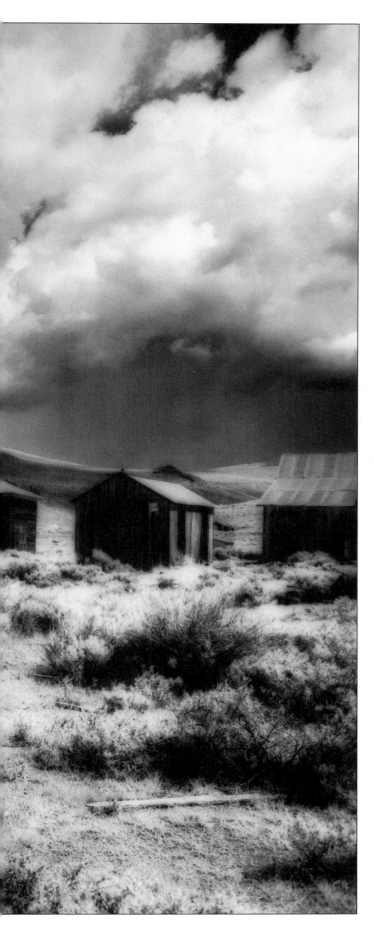

■ Composition

A storm rolling in provided some interesting clouds for this shot. The sky can be a fantastic source for any shot in need of drama or presence.

■ Depth

Depth is an element that must almost always be dealt with. Although there are times when a photographer intentionally creates a shot where the focal plane is greatly reduced or flattened, more often than not depth is something that a photographer tries to take advantage of. When the photographer fails to consider depth, it is apparent in the final print.

■ Contrast

Infrared film in general tends to create high contrast images, which means fewer tones exist between deep blacks and brilliant whites. Because of this limited range, areas of similar tones can appear to merge within the image, resulting in a loss of separation between the objects. This can create spatial oddities within the image and make it difficult to read.

■ Backlighting

This backlighting experiment certainly surprised me with the amount of detail retained in the shadow of the overhead beam. I fully expected the beam to reproduce as black with very little or no detail in the shadow area. Because of the backlighting, I had to open up to capture this detail.

■ In the Darkroom

As a result of opening up a stop, the landscape to the right was rather dense and required extra burning in the darkroom, a small price to pay for an interesting shot.

■ The Sky

Notice how the sky takes on an extreme gradation from white to black. This is the typical gradation and is the manner in which infrared renders skies. However, the sun is in a low position in the sky, so the gradation is tilted at an unusual angle. This fading of black to white isn't something the photographer can control, although choosing different times of day and angles of the sun may offer slight control over the effect.

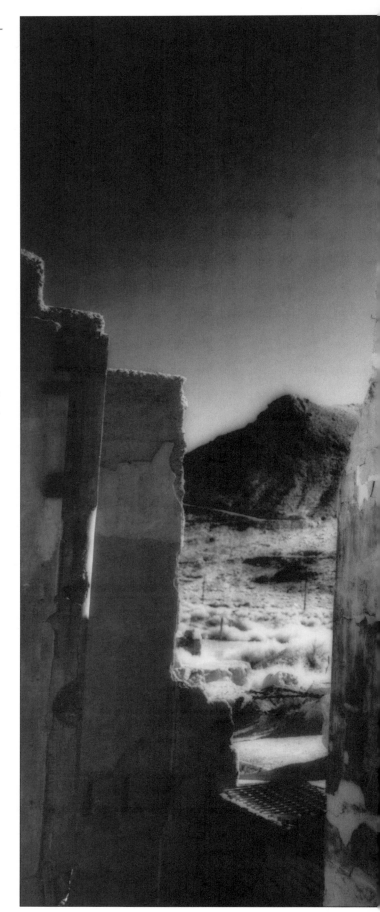

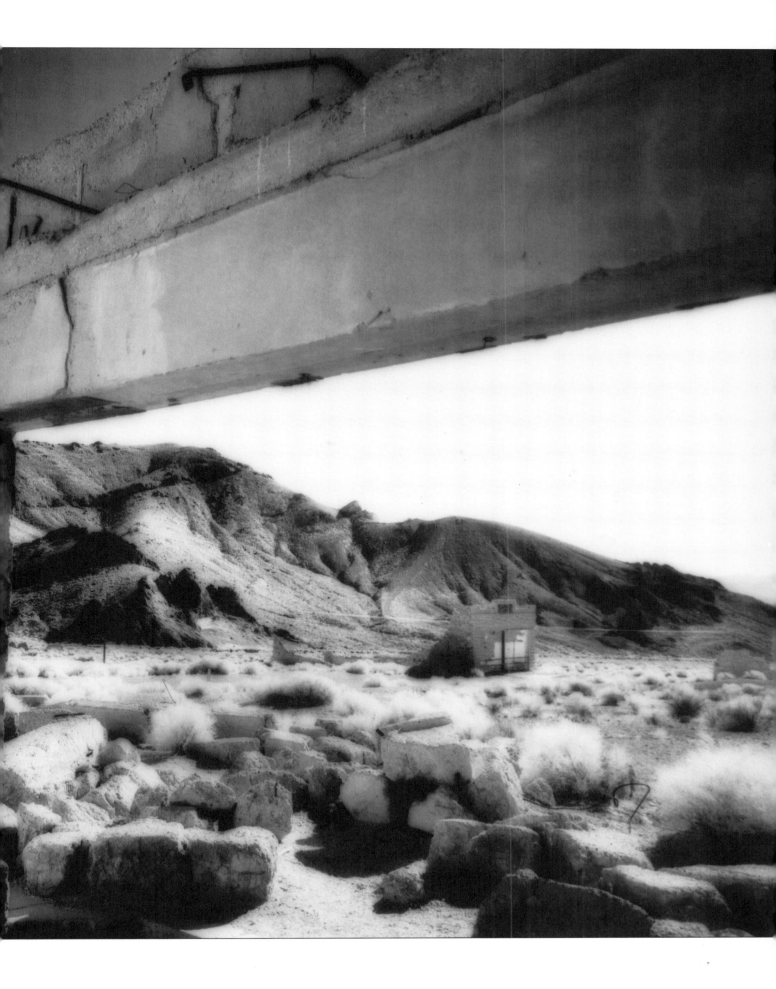

■ Composition

This will always be one of my favorite shots simply because of how well the elements are arranged. After seeing how the worn and weathered surfaces at Bodie translated with infrared film, I immediately began shooting subjects that had that weathered appearance. These brilliant white columns with the broken stone and doorway in between presented an obvious composition.

■ Exposure

Due in part to the high altitude of the location, shooting the white stones required stopping down so as to reduce the chance of overexposing the highlights.

■ In the Darkroom

Be careful when printing a scene with brilliant white highlights. It's easy to burn in the highlights too much, creating a flat and muddy image.

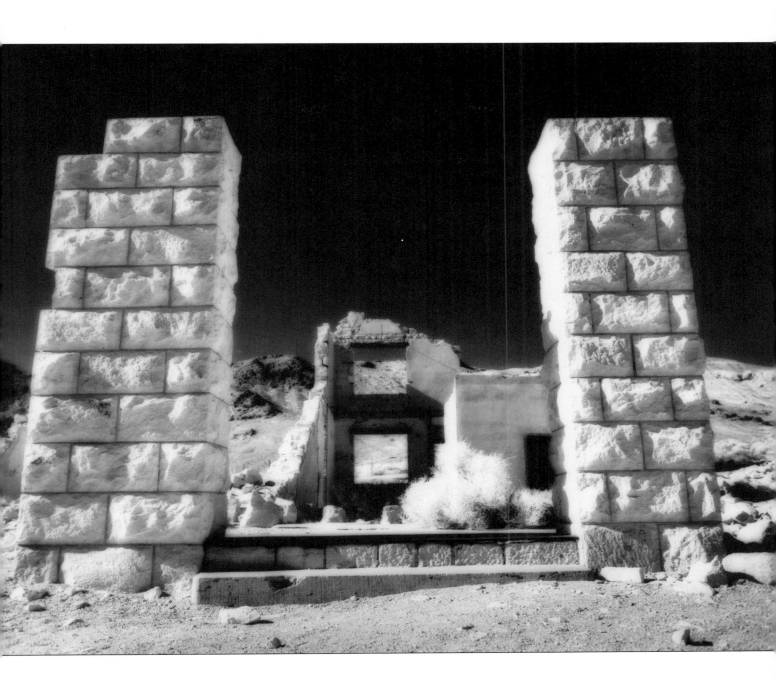

■ Composition

This building was constructed of brilliant white stone which I felt would create a dramatic shot. The large stones in the foreground that grow smaller as they fade into the hillside give the viewer a strong sense of depth. This helps compensate for the blackened sky which usually flattens a shot. To capture a little more depth in the image, I stood on a large stone for some extra elevation.

■ Exposure

Because of the bright tones of the white building, I had to I stop down so as not to overexpose the highlights.

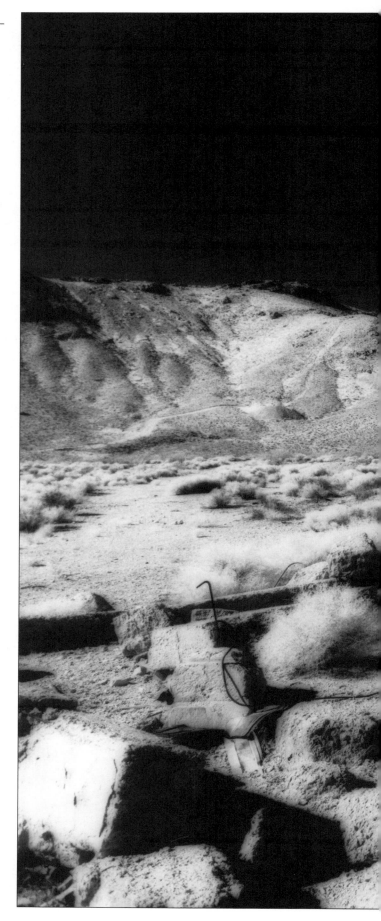

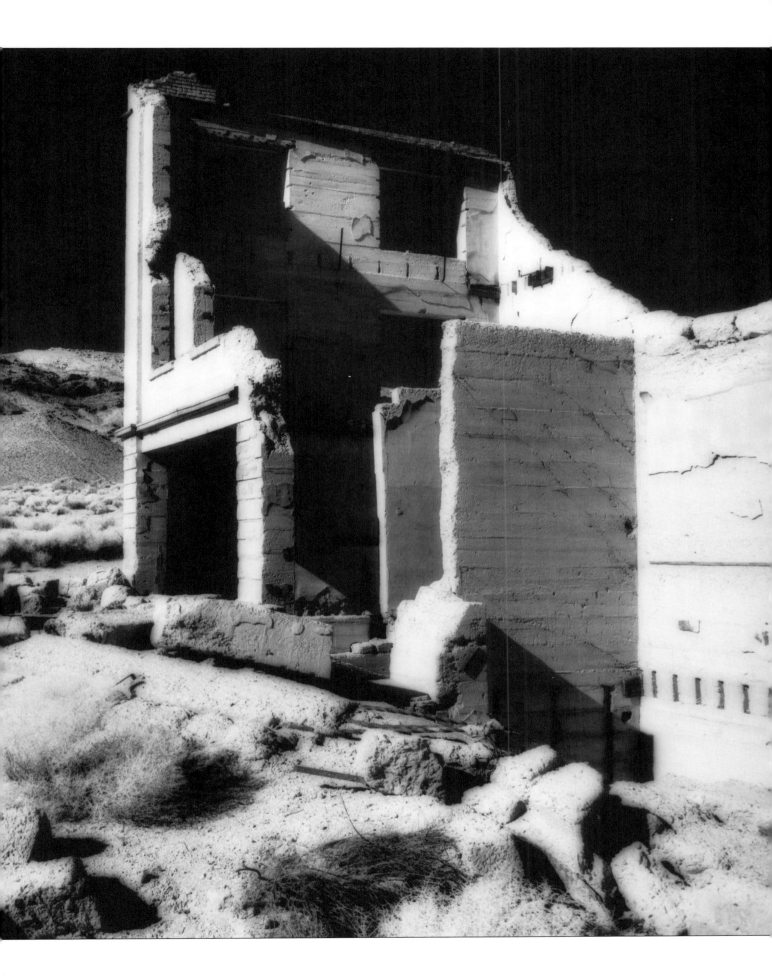

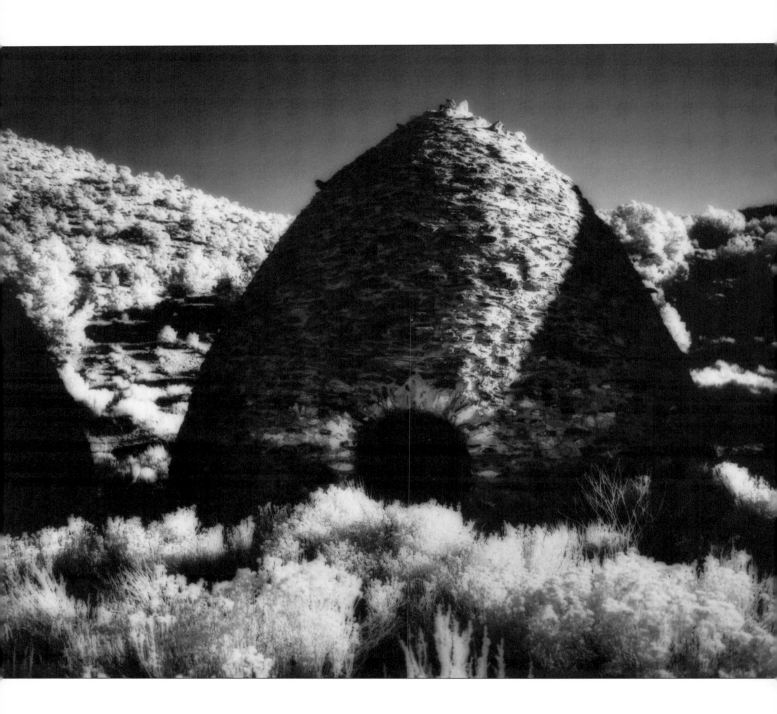

■ Composition

The unusual shape of these kilns appealed to me. They stand about fifteen feet tall, so I positioned the camera about twenty feet away. I composed this so that the desert weeds in the foreground would serve as a highlight in front of the shadow area that lies just behind them. This gives the image a wide range of tones.

■ Light

At the risk of overstating the obvious, the lighting is *the* key element in any good photograph. In most instances, it can be manipulated or taken advantage of either by pursuing alternate compositions or simply by shooting at a different hour of the day. I have mentioned a number of times the importance of shooting in rather clear, sunny weather. This is important indeed, but the time of day will also have an enormous effect on the final product. Once you shoot a few rolls of infrared, you will begin to get a feel for how the film deals with various lighting situations. This will enable you to begin to better predict the results of various lighting and compositions.

■ Low Light

This is the result of shooting without bright, clear skies. The entire day had a hazy overcast element that refused to go away, so I had no choice but to wait for brief moments when the sun managed to poke through. A little extra sunlight is what is necessary if the photo is going to have any contrast. And here it was just enough to give the shot some deep shadows. Two aspects of shooting in poor/low lighting are the slowing of an already slow film and the reduction of the infrared effect on the subject, neither of which is desirable.

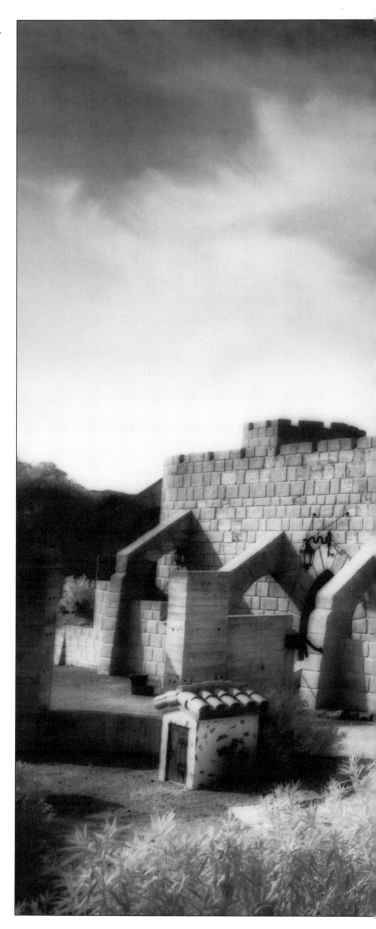

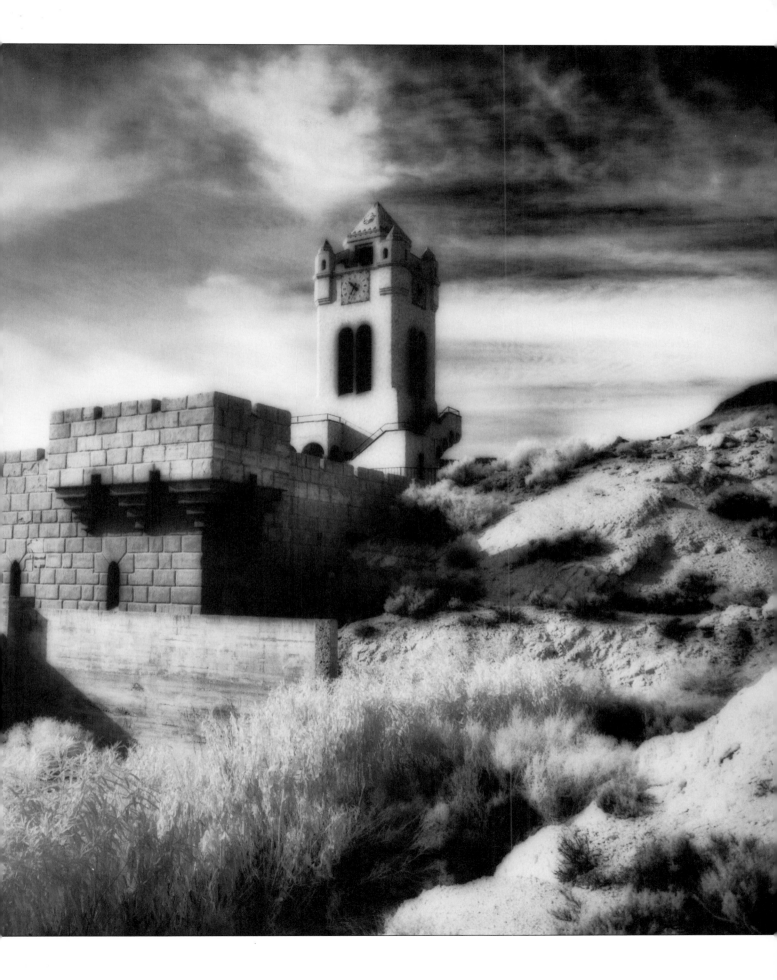

■ Horizon Effects

This shot demonstrates how infrared film renders clear, wide open skies. With warm weather and clear skies, the infrared waves are more abundant on the horizon than elsewhere across the sky. As a result, the horizon tends to reproduce with a white horizontal area which varies a little with each shot depending on temperature, location, time of day and altitude. When composing a shot, try to imagine the shot with the horizon line because it can be of use when composing images that require some separation between the foreground and the sky.

■ Composition

Mono Lake is surrounded by these large unusual rock formations that reach heights of around ten or fifteen feet. I wanted a shot of one of the small towers with the lake in the background. To get the elevation I needed to properly frame the scene, I found a larger rock to shoot from. I intentionally composed the photograph with the rock formation placed just above the horizon. This ensured that the horizon line would not bisect the formation, and allowed me to take advantage of the light colored horizon to make the formation stand out.

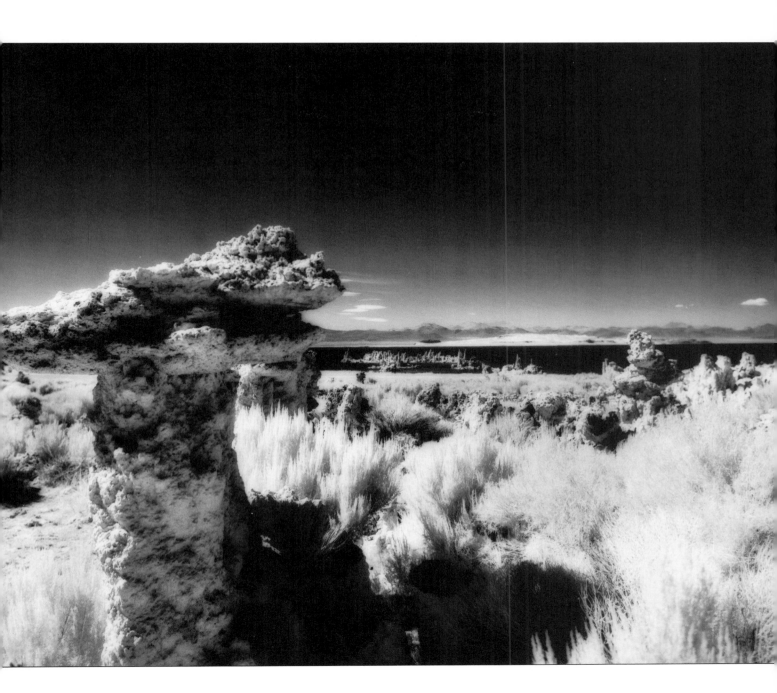

Index

Background, 36, 99
Backlighting, 65, 112
Bleaching, 89
Bracketing, 67, 80, 83
Burning, 44, 51, 104
Camera
 format, 94
Clouds, 34, 84, 109
Color, 19
Composition, 12, 21, 22, 29, 32, 36, 39, 40, 44,
 47, 48, 58, 62, 68, 74, 76, 79, 83, 99, 102,
 104, 107, 109, 111, 114, 116, 119, 122
 horizontal vs. vertical, 58, 79
Contrast, 11, 34, 39, 54, 67, 76, 89, 94, 104, 111
Darkroom, 44, 47, 51, 74, 83, 94, 102, 112, 114
 set-up, 83
 see also Bleaching, Burning, Dodging,
 Enlarger, Prefogging, Printing,
 Processing, Selenium toning, Sepia
 toning
Depth, 36, 58, 68, 70, 111
Diffusion printing, see Printing
Dimension, 68
Dodging, 31, 44, 47
Enlarger, 84, 86, 104
Evaluating your work, 76
Experimentation, 56
Exposure, 4, 6, 12, 16, 32, 40, 54, 67, 83, 99, 100,
 102, 114, 116
Film, 4-8, 81
 grain, 8
 sharpness, 81
Filters, 72
Flash, 16, 58, 68
Focusing, 6
Fog, 76
Foreground, 36, 48, 83, 116
Highlights, 26, 31, 34, 40, 48, 116
Horizon, 122
Infrared
 characteristics, 8, 19, 67, 120
 defined, 4
 film, see Film
 potential, 100

Lenses
 wide angle, 51, 60
Lens hood, 72
Light, 11, 19, 43, 53, 54, 56, 65, 68, 90, 104, 119
 evaluating, 109
 late day, 40, 47
 overcast, 92, 120
 see also Sun
Locations, 4, 36, 70, 107
Metering, 40, 67
Mistakes, 39
Motion, 68
People, 39, 48
Planning, 74
Portfolios, 90
Prefogging, 86
Printing, 31, 104
 diffusion, 84, 102
 see also, Prefogging
Processing, 6, 92
Readability, 21, 24
Records, 92
Reflections, 102
Reflectors, 16, 58
Reflectivity, 19
Routine, 65
Selenium toning, 26
Sepia toning, 89
Shade, 32, 54
Shadow formation, 24, 32, 34, 44, 74, 76, 79, 81,
 83, 89, 120
Sky, gradation, 48, 112, 122
 see also, Horizon
Sun, 34, 48, 51, 56, 62, 65, 79
Sunset, 40
Surprises, 84
Texture, 19, 26, 31, 67, 72, 90
Tonalities, 54
Toning, see Sepia, Selenium
Tripod, 70
Vignettes, 14, 26, 97
Weather, 109, 119
Wide angle, see Lenses

Other Books from Amherst Media, Inc.

Build Your Own Home Darkroom
Lista Duren & Will McDonald

This classic book shows how to build a high quality, inexpensive darkroom in your basement, spare room, or almost anywhere. Information on: darkroom design, woodworking, tools, and more! $17.95 list, 8½x11, 160p, order no. 1092.

Into Your Darkroom Step-by-Step
Dennis P. Curtin

The ideal beginning darkroom guide. Easy to follow and fully illustrated each step of the way. Information on: equipment you'll need, set-up, making proof sheets and much more! $17.95 list, 8½x11, 90p, hundreds of photos, order no. 1093.

Camera Maintenance & Repair Book 1
Thomas Tomosy

A step-by-step, fully illustrated guide by a master camera repair technician. Sections include: testing camera functions, general maintenance, basic tools needed, basic repairs for accessories, camera electronics, plus "quick tips" for maintenance and more! $29.95 list, 8½x11, 176p, order no. 1158.

Camera Maintenance & Repair Book 2
Thomas Tomosy

Advanced troubleshooting and repair building on the basics covered in the first book. Includes; mechanical and electronic SLRs, zoom lenses, medium format, troubleshooting, repairing plastic and metal parts, and more. $29.95 list, 8½x11, 176p, 150+ photos, charts, tables, appendices, index, glossary, order no. 1558.

Restoring Classic & Collectible Cameras
Thomas Tomosy

A must for camera buffs and collectors! Clear, step-by-step instructions show how to restore a classic or vintage camera. Work on leather, brass and wood to restore your valuable collectibles. $34.95 list, 8½x11, 128p, b&w photos and illustrations, glossary, index, order no. 1613.

Infrared Photography Handbook
Laurie White

Covers black and white infrared photography: focus, lenses, film loading, film speed rating, heat sensitivity, batch testing, paper stocks, and filters. Black & white photos illustrate how IR film reacts in portrait, landscape, and architectural photography. $24.95 list, 8½x11, 104p, 50 b&w photos, charts & diagrams, order no. 1419.

The Art of Infrared Photography / 4th Edition
Joe Paduano

A practical, comprehensive guide to the art of infrared photography. Tells what to expect and how to control results. Includes: anticipating effects, color infrared, digital infrared, using filters, focusing, developing, printing, handcoloring, toning, and more! $29.95 list, 8½x11, 112p, order no. 1052.

Infrared Nude Photography
Joseph Paduano

A stunning collection of images with informative how-to text. Over 50 infrared photos presented as a portfolio of classic nude work. Shot on location in natural settings, including the Grand Canyon, Bryce Canyon and the New Jersey Shore. $29.95 list, 8½x11, 96p, over 50 photos, order no. 1080.

Achieving the Ultimate Image
Ernst Wildi

Ernst Wildi shows how any photographer can take world class photos and achieve the ultimate image. Features: exposure and metering, the Zone System, composition, evaluating an image, and much more! $29.95 list, 8½x11, 128p, 120 B&W and color photos, index, order no. 1628.

Black & White Portrait Photography
Helen T. Boursier

Make money with B&W portrait photography. Learn from top B&W shooters! Studio and location techniques, with tips on preparing your subjects, selecting settings and wardrobe, lab techniques, and more! $29.95 list, 8½x11, 128p, 130+ photos, index, order no. 1626.

Special Effects Photography Handbook

Elinor Stecker Orel

Create magic on film with special effects! Little or no additional equipment required, use things you probably have around the house. Step-by-step instructions guide you through each effect. $29.95 list, 8½x11, 112p, 80+ color and b&w photos, index, glossary, order no. 1614.

Profitable Portrait Photography

Roger Berg

Learn to profit in the portrait photography business! Improves studio methods, shows lighting techniques and posing, and tells how to get the best shot in the least amount of time. A step-by-step guide to making money. $29.95 list, 8½x11, 104p, 120+ B&W and color photos, index, order no. 1570.

Lighting Techniques for Photographers

Norm Kerr

This book teaches you to predict the effects of light in the final image. It covers the interplay of light qualities, as well as color compensation and manipulation of light and shadow. $29.95 list, 8½x11, 120p, 150+ color and b&w photos, index, order no. 1564.

Computer Photography Handbook

Rob Sheppard

Learn to make the most of your photographs using computer technology! From creating images with digital cameras, to scanning prints and negatives, to manipulating images, you'll learn all the basics of digital imaging. $29.95 list, 8½x11, 128p, 150+ photos, index, order no. 1560.

Handcoloring Photographs Step-by-Step

Sandra Laird & Carey Chambers

Learn to handcolor photographs step-by-step with the new standard handcoloring reference. Covers a variety of coloring media. Includes colorful photographic examples. $29.95 list, 8½x11, 112p, 100+ color and b&w photos, order no. 1543.

The Wildlife Photographer's Field Manual

Joe McDonald

The complete reference for every wildlife photographer. A practical, comprehensive, easy-to-read guide with useful information, including: the right equipment and accessories, field shooting, lighting, focusing techniques, and more! Features special sections on insects, reptiles, birds, mammals and more! $14.95 list, 6x9, 200p, order no. 1005.

Black & White Nude Photography

Stan Trampe

This book teaches the essentials for beginning fine art nude photography. Includes info on finding your first models, selecting equipment, scenarios of a typical shoot, and more! Includes 60 photos taken with b&w and infrared films. $24.95 list, 8½x11, 112p, index, order no. 1592.

Amherst Media's Customer Registration Form

Please fill out this sheet and send or fax to receive free information about future publications from Amherst Media.

CUSTOMER INFORMATION

DATE

NAME

STREET OR BOX #

CITY **STATE**

ZIP CODE

PHONE () **FAX** ()

OPTIONAL INFORMATION

I BOUGHT *INFRARED LANDSCAPE PHOTOGRAPHY* **BECAUSE**

I FOUND THESE CHAPTERS TO BE MOST USEFUL

I PURCHASED THE BOOK FROM

CITY **STATE**

I WOULD LIKE TO SEE MORE BOOKS ABOUT

I PURCHASE **BOOKS PER YEAR**

ADDITIONAL COMMENTS

FAX to: 1-800-622-3298

①

②

Name_____
Address_____
City_____State_____
Zip_____ — _____

Amherst Media, Inc.
PO Box 586
Buffalo, NY 14226

③